Buckeridge, Bainbrigge

A Facsimile Reprint
Published by Cornmarket Press
London 1969

First Edition 1706
Second Edition 1744
Third Edition 1754

Published by Cornmarket Press Limited
42/43 Conduit Street London W1R 0NL
Printed in England
7191 2075 6

Bainbrigg Buckeridge, the author of
*An Essay towards an English School of
Painting* had moved in Dryden's circle, for
he lamented his death as a friend as well as
an admirer, in a poem to Kneller, printed in
Luctus Britannici (London 1700). His
poem's theme was Kneller's portrait of
Dryden holding the poet's bays. The *Essay*
first appeared in 1706 at the end of a
translation of Roger de Piles' celebrated
Abrégé de la vie des Peintres (Paris 1699).
The *Abrégé* was Englished by John Savage
(1673–1747), in his early life one of the
numerous professional translators and
compilers of the Augustan age. Savage
translated from French, Spanish, and Latin,
or abridged the Turkish history indifferently,
and there is no reason to think that he knew
anything of art. Probably he, also knew

Dryden, for he translated part of the *Miscellaneous Essays* (1692) of St Evremond, to which Dryden prefixed a "character" of the author. One or two notes appended to passages in De Piles suggest in their use of the pronoun *we* that Buckeridge assisted Savage in his translation, having doubtless been called in to give expert counsel. And the dedication to Colonel Robert Child (d. 1721), elder son of Sir Francis Child (1642–1713), the founder of Child's Bank and owner of a celebrated collection of pictures, is too evidently the work of an enthusiast familiar with the theory and history of art not to be almost entirely by Buckeridge. In one or two paragraphs "I" changes abruptly to "we": these were obviously cobbled in by Savage.

That Buckeridge wrote the *Essay* has been vaguely known since 1754, when his authorship was disclosed in the preliminary note to the life of Kneller, but Buckeridge himself has never yet been properly identified. Fortunately the curtain that veils his polite and charming person can be partly

lifted. The Buckeridges were a family of Berkshire yeomen who had entered trade and climbed into gentility during the 17th century. By marriage they were kin of Sir Thomas White (1492–1567), Lord Mayor of London, who founded St John's College, Oxford, in 1555. The most distinguished of them all, the High Church divine John Buckeridge (1562?–1631) had been President of St John's before becoming Bishop of Rochester in 1611 and Bishop of Ely in 1628. Nicholas Buckeridge, Bainbrigg's father, was the grandson of the Bishop's brother, Thomas of Basildon. He was an East India Company merchant, and resided at Gombroon (Bander Abbas) and Ispahan between 1647 and 1669, going as Supervisor to Fort St George, as Madras was then called, in 1664. He married Sarah daughter of William Baynbrigge of St Giles in the Fields, where he too resided, as well as having a house at Northall, in Hertfordshire. Bainbrigg was born in 1668. He matriculated at St John's College on 25 June 1691, aged 23, which suggests

that he had already been educated elsewhere,
or been in some way prevented from coming
up earlier. He proceeded BA in 1695,
presenting that same year to the College a
portrait of Archbishop Laud, who had been
both Fellow and President.

According to Giles Jacob, writing in 1720,
when Buckeridge was still alive, he had
been "designed for the Study of Physick:
but his Genius leading him to Drawing and
Painting, he Travelled in his Younger
Years; and in *Holland*, and other foreign
Parts, made some Progress in that curious
Art, which has been his chief Amusement
in a Country Retirement; and next to that,
his Inclinations have led him to Poetry. In
the late Reign, he had some Employments
under his Grace the Duke of
Buckinghamshire, with whom he has
always been in favour". John Sheffield
(1648–1721) successively Earl of Mulgrave,
Marquess and then Duke of Normanby
and of the County of Buckingham
was not only great about court, but was a
wit and poet, and the friend, patron and

collaborator of Dryden. A Privy Councillor and Lord Chamberlain under James II, he submitted to William III, but soon joined the Tory opposition and was dismissed from office. Under Anne he was Lord Privy Seal from 1702–5 and after a second period out of office became Lord President of the Council from 1710–14. He was a leader of the Tory party and though the nature of Buckeridge's employments under him is not known, the connection suggests that Buckeridge himself, as might be expected of his High Church background and sympathies, was a strong Tory. If so, his country retirement may have begun in 1714, when the arrival of George I sent the Duke out of office and all hope of office.

In 1704 Buckeridge addressed a long poem to the Duke, describing Buckingham-House (now Palace), newly built by the Duke and decorated with frescoes and ceiling paintings by Laguerre and Ricci during that belated flight of Baroque history-painting which had first taken wing during the last quarter of the

century and was to last until c. 1730.

The poem praised the house - "Palladio with the firm Bramante join'd" - , and the Duke's collection of pictures including "great Titian's labours", "Rubens' draughts", "Raphael's skill", as well as where:

> "The bold Bourgonion shews in bloody
> field
> How all to Roman art and valour yield;
> Correggio does harsh Perugino grace,
> By fam'd Van Dyk with wondrous charms
> a face,
> And Julio rang'd with the Carracci's
> race".

The Duke himself is lauded as a Maecenas and as a poet. Another poem of the same year is addressed to "Signior Antonio Verrio, at Hampton Court" on the grant of Woodstock to Marlborough, and sketches out a programme, including a full Baroque apotheosis of the Duke, to be executed by Verrio for the decoration of the future Blenheim, a commission the artist died too soon to receive. Buckeridge's last known English poem is not concerned with art,

but with the "bleeding conquests" of the "charming Galatea", Lady Mary Chambers, on the occasion of her departure for Turkey with her ambassador husband, Sir Thomas. All the poems are in polished heroic couplets. Jacob also says that Buckeridge translated "a Novel from the *Spanish* of the famous *Cervaantes*": this has not been identified.

In 1708 Buckeridge married Rebecca Atkyns, almost certainly the daughter of Sir Robert Atkyns (1647–1711), the topographer and historian of Gloucestershire. She died, leaving him with a daughter, and Buckeridge married as his second wife, probably c. 1715, Mary, daughter and heiress of Sir William Goring, last baronet, of Broadwater and Goring in Sussex. Buckeridge died on 11 January 1733. One of his three obituary notices says that he was of Hackney and all, mysteriously, that he had formerly been in the East India Company's service at Fort St George. A search in the East India Company's records has failed to trace him at Madras. His will, dated 25 November 1732, and proved

5 February 1733, is a vivid record of his taste in pictures, of his pleasure in drawing, and of his furnishings. Unfortunately no portrait of him—surely there was one by Kneller?—has been discovered. The will reads:

"I Baynbrigg Buckeridge of Highgate in the parish of Hornsey Middx . . . ffirst I desire my Bones may be mingled with the Ashes of my Dear and innocent Child at Westham Church to be carried privately with Two or Three Coaches without Escutcheons or pall bearers only Three or ffour ffriends and some of my Children to see me laid in their Brothers Grave. I desire to be remembered no otherwise by any Inscription but this in a plain Marble against the Church Wall Here lyes Tho Buckeridge son of B.B: &c as on his Tombestone" He bequeathed the moiety of a house in Cheapside to Mary, his daughter by his first marriage, and her children, and also "the red flowered silk Safoy with the Cushon covers for the Chairs of the same and alsoe the Chairs to which they belong

with the Calicoe Cushions the Second best
ffeather bed the White or the coloured
Indian Quilt her Chest of Drawers and Glass
Book Case the large Looking Glass in a
black fframe bought by her Mother her
Watch a large Bible her Books . . . The
pictures of Sr. Edward and Sr. Robert
Atkyns of her dear Mother her own of
Lady Mary Chambers and of Mr Manbert
drawn by Dahl with a Coppy to be done
from one of my Pictures at about Two
Guineas Expense Two fflower pott Pictures
by Montingo a Picture drawn by me of
Eaton and part of Winsor Castle a pair of
Pictures with fflowers and Grapes drawn on
looking Glass with a Ladys head drawn on
a Three Quarter Cloath by Sr. Godfrey
Kneller one of the Two large China Dishes
one large Bason and Six China Plates
brought from India by my ffather I give
unto my youngest son Nicholas as far as I
can give by Will as near as may be don by
his Mothers Partition One halfe of the
Estate which came by her in Sussex . . .
also . . . my house at Highgate after my

wifes life if she shall think fitt to Inhabit the same" at £10 a year rent. "I alsoe give him halfe my English Books and if he shall be bred a Schollar all my large Books relateing to Divinity his dear Mothers Picture drawn by Moreland and his owne and one of my pictures with Two Landskips drawn by me as he shall choose his Godfathers with his wifes picture. I give Rings of one pound vallue to M^r Plaxton M^r Manbert, M^r Yardley and M^r Liptrot To my Eldest Son I give my wifes Picture by S^r. Godfrey Kneller my own by Dahl his own and Six of my drawing with the rest of my books and papers." After the marriage of this eldest son, Henry-Bainbrigg, he was to receive the household stuff, plate and "halfe my other pictures" Mrs Buckeridge was made executrix. After her death the rest of his substance was to go to the two sons.

HIS BOOK

The first account of ancient and modern artists
to appear in English was inserted in 1591
by Sir John Harington into the *Annotation*
to his translation of Canto XXXIII of
Ariosto's *Orlando Furioso*. His modern
artists were all Italian, with the exception of
Hilliard, panegyrised as the nonpareil of the
art of limning. For although English
authors often wrote glowingly of Northern
art—Dürer, Lucas van Leyden and
Goltzius were lauded here repeatedly
throughout the first half of the seventeenth
century—it was orthodox opinion that the
artists who had raised painting from
mediaeval barbarism to its modern perfection
were all Italian. Peacham too gives only lives
of Italian artists in his *Compleat Gentleman*
(1622), though he had been obliged to make
his abstracts from Karel Van Mander, not
being able to lay hands on a Vasari.
Harington and Peacham both end with the
High Renaissance, when painting was
thought to have come to its maturity, and
even William Aglionby, writing in 1685,
ends the selection of lives he took from

Vasari for his *Painting Illustrated* with
Titian, though promising a second part
"which, besides some more refined
Observations upon the *Art* it self, will contain
the *Lives* of all the *Modern Painters* of any
Note, from the Time of the *Caraches* to our
Days, and an Account of its present State
all *Europe* over". Such was the primacy of
painting in seventeenth century eyes that
sculptors were virtually ignored: Aglionby
excerpted only the life of Donatello.

In Italy eulogies and biographies of artists
were already being written in the fifteenth
century, usually as part of general collections
of notices of illustrious men. The biography
of artists was fully established as an
independent genre by Vasari in the 1550s
and 1560s. His example was not followed in
other European countries until the
seventeenth century, the first great period of
picture-collecting and connoisseurship. The
Netherlands, as befitted their importance,
second only to that of Italy, in European
painting, were first with van Mander's *Het
Schilderboek* (1603–4), but in Germany

Sandrart's *Teutsche Akademie* did not appear until 1675–79, and French artists had to wait until the publication of Félibien's *Entretiens* (1666–88). All these books treated the Italian masters before proceeding to their own national artists. So too the first lives of English artists were the five or six included by Richard Graham in his *Short Account of the most Eminent Painters both Ancient and Modern, Continu'd down to the Present Times According to the Order of their Succession*, printed in 1695 as a supplement to Dryden's translation of Du Fresnoy's *De Arte Graphica*, or rather of De Piles' paraphrase of the poem. They had not been obtained easily: Graham complains "I am asham'd to acknowledge how difficult a matter I have found it, to get but the least Information touching some of those Ingenious Men." Graham's critical standards are clearly expressed. A thorough supporter of the new Franco-Roman classicism—he was an admirer of "that excellent Treatise of Gio:Pietro Bellori"—he deliberately excluded from his little book many German

and Netherlandish painters, condemning
their manner as "generally *Gothique, Hard*
and *Dry*". Even of Gherardt Dou, whose
colour and finish he admired, he says "we
must not expect to find in his *Works* that
Elevation of *Thought*, that *Correctness* of
Design, or that *noble Spirit*, and *grand Gusto*,
in which the *Italians* have distinguish'd
themselves from the rest of *Mankind*."

The *Essay towards an English School*
is the first attempt at a history of English
painters. In the dedication Buckeridge
claims sole authorship of it, but when his
life of Kneller was added to the third edition
in 1754, the note preceding it stated that
he had "written the greatest part of the
lives . . . at the request of Mr Savage". The
explanation of this slight discrepancy is
probably that Buckeridge, having borrowed
heavily from Graham in his lives of the
Gentileschis, Van Dyck, Cooper, Dobson,
Lely and Riley, later scrupled to claim
the entire *Essay* as his own. Indeed he
explicitly owns these borrowings in the
dedication, regretting that Graham had

wanted leisure and inclination to write a history of the English School. His other sources were probably oral.

In the preface of his *Anecdotes* Walpole curtly dismissed the *Essay* as superficial and as useless for anything "before modern times". This is an antiquarian's judgment, Vertue and Walpole having pushed their researches into the Middle Ages as far back as they knew how to go. Buckeridge did not propose to investigate the early history of painting in England, but to give an account of those artists whose painting was acceptable to the taste of the age. He really begins with Holbein, who is also annexed for England in a note to De Piles's biography, but all succeeding painters are omitted, with implicit contempt, until Hilliard. In this exclusiveness Buckeridge followed the current concept that defined a school according to a fixed aesthetic canon. De Piles, for example, admits into the *Abrégé* only those pre-Renaissance artists who contributed significantly to the progress of painting towards the Renaissance style. Yet

though Buckeridge sets the Italian *gusto* at the head of his hierarchy of values, he liked the Northern flower-paintings, landscapes and portraits that Graham, with his classical taste, found dull and unimaginative, and he admits many painters whom Graham might have disregarded. Doubtless his travels in Holland had influenced his taste, and certainly his lives, even those taken from Graham, are critically much richer. This greater receptiveness makes the *Essay* a most faithful and sympathetic account of painting in seventeenth century England, as well as the first major biographical source-book for English art. Of course Buckeridge was partly moved to admit so many painters by his anxiety to prove that in number and excellence English painters far exceeded those of our hated rivals, the French. This is why he claimed as English so many painters who merely worked here. The handing-down of stylistic and other traditions implied in the very name "school" evidently meant little or nothing to him, at least when patriotism spoke. The single

biographies are explicitly modelled on those of De Piles, who believed that the biography of artists was in itself of small account. The salient biographical facts for each painter, the genres in which he worked, his principal pictures, his manner, its sources, characteristics, faults and merits, his place in the scale of merit, were alone of real concern.

The *Essay* was reviewed in the *Journal des Sçavans* on 2 January 1708. The last paragraph of the review reads:

"Comme nous ne rendons pas ici compte au Public du Livre de M. de Piles, nous ne nous étendrons pas davantage sur la Traduction. L'Auteur n'en est point nommé. Il semble ne pas trouver bon que M. de Piles ait paru négliger les Peintres Anglois, dont plusieurs, selon lui, ont eu beaucoup de mérite en divers genres. Et c'est ce qui l'a porté a donner ici la vie d'environ cent Peintres de sa Nation, dont plusieurs cependant ne sont censés Peintres Anglois que pour avoir travaillé en Angleterre, & y avoir passé du tems. Et c'est l'assemblage

de tous ces Peintres, qu'il honore du nom d'Ecole d'Angleterre. Cette maniere de donner a un pays les Peintres qui y ont travaillé, est assez ordinaire aux Auteurs qui ont écrit de la vie des Peintres. Du reste, la plûpart de ceux dont l'Auteur fait l'éloge, ont plutôt excellé dans les Portraits, & a peindre des Fruits, & des Fleurs, &c. ou dès Paysages qu'a faire des Tableaux d'Histoire."

The edition of the *Essay* reprinted by Cornmarket Press is that of 1754, so taking in Buckeridge's life of Kneller, first added in the third (1754) edition, and the life of Sir James Thornhill from the *Lives of the most eminent modern painters* (London 1754) which James Burgess extracted with amendments from Dézallier d'Argenville's *Abrégé de la vie des plus fameux peintres* (Paris 1745) the source indeed of all these supplementary lives that he added to the third edition.

Berry, W. *County Genealogies: Pedigrees of Berkshire families*, London, 1837, p. 51

The Chronological Diary For the Year 1733, London, 1733, p. 7.

Cokayne, G. E. & Fry, E. A. *Calendar of Marriage Licences issued by the Faculty Office*, London 1905, p. 236.

Foster, J. *Alumni Oxonienses*, i, Oxford 1891, p. 204.

The Gentleman's Magazine, 1733.

Jacob, G. *An Historical Account of the Lives and Writings of Our most Considerable English Poets* (really vol. 2 of *The Poetical Register*) London, 1720, pp. 21–22.

The London Magazine, 1733, p. 44.

Nichols, J. *A select collection of poems: with notes, biographical and historical*, v, London 1772, pp. 158–168. This collection reprints all English poems issued by Buckeridge in his lifetime.

Piles, R. de, trans. J. Savage & B. Buckeridge. *The Art of Painting and the Lives of the Painters: containing, A Compleat Treatise of Painting, Designing, and the Use of Prints: With Reflections on*

*the Works of the most Celebrated Painters,
and of the several Schools of Europe, as
well Ancient as Modern. Being the
Newest, and most perfect Work of the Kind
extant. Done from the French of Monsieur
de Piles. To which is added, An Essay
towards an English - School, With the Lives
and Characters of above 100 Painters.*
London 1706. Reprinted 1744 and 1754.

Poole, Mrs. *Catalogue of portraits in . . .
Oxford*, iii, 2, Oxford, 1925, pp. 166–167,
No. 28.

MSS

M.S. Rawlinson J. 4°. I, f. 433 in Bodleian
 Library (Summary Catalogue no. 15068).
 A transcript of Jacob with inaccurate
 additions.

M.S. Rawl. C. 155, f. 368v in Bodleian
 Library. Copy of Sapphics by
 Buckeridge entitled 'Musica sacra
 Dramatica sive oratorium.'

*I should like to thank Dr. Jonathan
Alexander, Mr. E. Croft-Murray, Mr. David
Foxon for help and information.*
R.W.L.

THE
ART of PAINTING,

WITH THE

LIVES and CHARACTERS

Of above 300 of the moſt Eminent

PAINTERS:

Containing a Complete Treatiſe of

PAINTING, DESIGNING,

AND

The USE of PRINTS.

WITH

REFLEXIONS on the WORKS of the moſt Celebrated MASTERS, and of the ſeveral *Schools* of *Europe*, as well ancient as modern.

Being the moſt perfect Work of the Kind extant.

Tranſlated from the French *of Monſieur* De PILES.

To which is added,
An ESSAY towards an ENGLISH SCHOOL.

The THIRD EDITION:
In which is now firſt inſerted the Life of Sir GODFREY KNELLER, by the late B. BUCKERIDGE, Eſq; who wrote the greateſt Part of the *Engliſh* School.

LONDON:
Printed for THOMAS PAYNE, in *Caſtle-Street*, next the *Mews-Gate*, near *Charing-Croſs*.

ROBERT CHILD, Efq;

S I R,

IT is one of the greateſt encouragements to moſt writers, that they generally addreſs to perſons who knowing little of the ſubject they treat of, it gives them an opportunity to ſay as many kind things as they pleaſe of their own productions, without fear of reprehenſion : But this advantage I have entirely loſt; for in ſpeaking of Painting to you, Sir, I ſpeak to one of the beſt judges of that noble art, which is not to be underſtood without penetration, delicacy, good ſenſe, a refined taſte, and a portion of that genius which inſpired the Painter in his performance. If I ſhould ſay things boldly to you, and as of my own knowledge, you would eaſily detect the deceit, and my preſumption would be more unpardonable than my ignorance. Yet, though I muſt be very cautious how I go out of my depth, leſt I ſink when I attempt to ſwim, I may venture farther on your candour and humanity than on my own judgment, were it to the full as good as I could wiſh it.

It is the happineſs, Sir, of men of your fortune, that they can read and ſee what they think fit for their pleaſure or inſtruction; but this benefit rather expoſes than improves many, who have not a true reliſh of the things about which they are curious. Vaſt libraries ill-choſen, are rather rubbiſh than curioſities; and numerous collections of pictures injudiciouſly made, are the ſport and contempt of the ſpectator, and a reflection on the owner. But when ſuch libraries and collections excel alike in number and value, they are treaſures of which the

greateſt

greateſt princes are proud. There is no gentleman in England who has any thing of this kind in greater perfection than yourſelf, who poſſeſs ſomething of ſeveral of the beſt maſters that are ſpoken of in the following treatiſe; and every day in your own houſe (the ornament of the fineſt ſquare in Europe) you behold ſome of the wonders that the hands of Paolo Veroneſe, Guido, Nicholas Pouſſin, Carlo Maratt, and other excellent artiſts have produced. By the nicety of your choice, the world admires that of your taſte, and are ſurpriſed to ſee ſo many rare things together in a country where Painting and the politer arts are not ſo much encouraged as in thoſe places, where, perhaps, the nobility and gentry are not ſo well qualified to judge of merit, nor ſo well able to reward it, as in England. Yet there are even here ſome few illuſtrious perſons, and men of worth and honour, who are ſolicitous for the proſperity of the arts, and contribute, by their ſtudies and bounty, towards making them flouriſh and prevail among us.

Painting is ſiſter to Poetry, the muſe's darling; and though the latter is more talkative, and conſequently more able to puſh her fortune; yet Painting, by the language of the eyes and the beauty of a more ſenſible imitation of nature, makes as ſtrong an impreſſion on the foul, and deſerves, as well as poetry, immortal honours.

Conſuls, Emperors and Kings, have entertained themſelves with the exerciſes of poetry, and exalted the muſe by the homage they paid her: as much is to be ſaid for Painting. One of the four houſes of the Fabii, as eminent as any in Rome, aſſumed the name of Pictor; for that Fabius, their anceſtor, painted the temple of Health, and was eſteemed the founder of the old Roman ſchool. More than one of the Emperors in the Bas Empire, ſpent many hours with a pallet and pencil; and, in the laſt century, Lewis XIII. learned to deſign of Vouet. The
late

late queen Mary, of glorious memory, and her fifter, our prefent gracious fovereign, queen Anne, were both inftructed in this art by Gibfon the dwarf. All the children of the queen of Bohemia, daughter to King James I. were taught to paint by Hontorft; and among the reft, the princefs Sophia, who, with her fifter the abbefs of Mabuiffon, fays Monfieur de Piles, *fe diftinguerent par l'habileté de leur pinçeau.* Alexander the Great was not fo fond of his miftrefs as of his Painter, for he parted with her to pleafe him; and our own King Charles I. delighted more in Painting than in all the other fciences, as much a mafter as he was of all. But you, Sir, are too well acquainted with the hiftory of the art to be pleafed with any information from me, nor does it want any other recommendation than the delight it at once affords the moft fublime faculty of the foul, the judgment, and the moft delicate fenfe of the body, the fight, to engage the protection of the curious: And as you are fo in a very high degree, I hope, Sir, this will be no ungrateful offering, fince, as far as our author is concerned, it is the moft complete and exact difcourfe of the kind that ever was publifhed in fo fmall a compafs.

The differtation before his lives of the Painters has been thought admirable by fevere critics, and the rules he lays down for Painting, fo juft, that they might ferve alfo for Poetry. I do not fay this, Sir, to biafs your opinion in his favour, that would be equally vain and arrogant; you are fo well acquainted with our author in his own language, that it will be eafy for you to judge whether he deferves the character which is given of him or not. He calls his account of the Painters lives an abridgment, and that with good reafon, for you will immediately perceive that he induftrioufly avoids entering into the detail of their actions. Indeed, the greateft of them, Leonardo da Vinci, Michael Angelo,

gelo, and Sir Peter Paul Rubens only excepted, did nothing of confequence enough, otherwife than as Painters, to give occafion for any thing to be faid of them worthy the notice of the public. In their private capacities, their lives were like the reft of the bulk of mankind, too mean for the pen of an hiftorian; and Monfieur de Plies has thought fit to let his fhort hiftory of them contain only fuch of their actions as ferved to give the world the beft idea of them as Painters. He has inferted none but what had fome relation or other to their art, and that was eafily done in a few pages, and fometimes in a few lines, unlefs he had defigned to write a hiftory of pictures, and not of Painters. I believe gentlemens curiofity, in this cafe, will go no farther than to know where the Painter was born, whofe difciple he was, what was his manner, how he executed it, which were his beft pieces, and when he died. Our author tells us in the Preface, that he had feen all the remarkable books of this kind; and after he had examined Vafari, Ridolfi, Carlo Dati, Baglioni, Soprani, the Count Malvafia, Pietro Bellori, Van-Mandre, Cornelius de Brie, Felibien, Sandrart and others, thought his abridgment neceffary as well as his differtation; for large volumes on the lives of private men, muft certainly contain many trivial things, and confequently prove tirefom. There are few who have leifure or application enough to run through ten or twenty books on an art which was intended chiefly for pleafure, though it has alfo its opportunities of inftructing, as is made appear, we hope, in the following tranflation.

His reafons had the fame weight with me in the Effay towards an Englifh School. I have written of the Englifh mafters more as they were Painters than as they were men: And yet I have, with much pains and trouble, gathered together, from the beft authorities, materials enough to make fome of the

<div align="right">lives</div>

lives larger than Monfieur de Piles has done his. I would not meddle with thofe mafters that are living, as well knowing that is a tender affair, and not to be touched without running the rifque of giving general offence *. If difcretion would have permitted me to do it, I might have enlarged and adorned our fchool fo much, that neither the Roman nor the Venetian would have had caufe to be afhamed of its company. At prefent it is more than a match for the French; and the German and Flemifh fchools, only excel it by the performances of thofe mafters whom we claim as our own. Hans Holbein and Vandyck are as much ours as Sebaftian of Venice belongs to the Roman fchool, Spagnoletto to the Lombard, or Ellis and De Champagne to the French: Nor have we a fmall title to Sir Peter Paul Rubens, for it was the protection and friendfhip of the duke of Buckingham that procured him the opportunities he had of diftinguifhing himfelf above others of his cotemporaries and countrymen of the fame profeffion. It was the duke of Buckingham that recommended him to the governor of the Netherlands, as a proper perfon to refide at the court of England, as the King of Spain's minifter. And it was here that he performed feveral of his beft pieces, and acquired the character of a ftatefman, which, no doubt, was a confiderable advantage to his reputation as a Painter.

But why fhould we be fo unjuft to ourfelves, as to think we ftand in need of an excufe, for pretending to the honour of a fchool of Painters as well as the French, who have been in poffeffion of it almoft as long as the Italians. You know, Sir, by the many beautiful pieces you have feen of the principal mafters of both nations, that if they have had their Vouets, their Pouffins, and le Bruns, we have had

A 4 our

* The account of Sir Godfrey Kneller is inferted in this third edition.

our Fullers, our Dobfons, and our Coopers; and have not only infinitely out-done them in Portraits, but have produced more mafters in that kind than all the reft of Europe.

We may alfo affirm, that the art is indebted to us for the invention of Metzotinto, and the perfection of crayon-Painting. By our author's account of Paftils, a name formerly given to Crayons, one may fee that the Italians had a very flight notion of a manner that is practifed here with fo much fuccefs. They made their drawings on a grey paper, with black and white chalk, and left the paper to ferve for the middle tint. Their colours were like ours, dry, without any mixture of oil or water. Our countryman, Mr Afhfield, multiplied the number and variety of tints, and painted various complexions in imitation of oil; and this manner has been fo much improved among us, that there is no fubject which can be expreffed by oil, but the crayons can effect it with equal force and beauty.

You, Sir, who are fo good a critic, and fo generous a patron of the art, cannot but wifh we had the fame advantage as other fchools have in an academy. It is true, we have feveral admirable collections, and your own in particular, whofe pieces are enough to inform the moft induftrious difciple, and infpire his genius to arrive at a maftery in the art. I have heard a famous Painter affert, that our Englifh nobility and gentry may boaft of as many good pictures, of the beft Italian mafters, as Rome itfelf, churches only excepted; and yet it is fo difficult to have accefs to any of thefe collections, unlefs it be to yours, Sir, who feem to have made your excellent collection as much for the public inftruction, as for your own private fatisfaction, that they are, in a great meafure, rendered ufelefs, like gold in mifers coffers. Had we an academy, we might fee how high the Englifh genius would foar; and as it excels all other nations in Poetry, fo, no doubt, it would equal,

if

if not excel, the greateſt of them all in Painting,
were her wings as well imped as thoſe of Italy, Flan-
ders and France. As for Italy, her academies have
kept her genius alive, or it would have expired
with her maſters, who firſt ſhewed ſhe had one, as
her genius in poetry died with Taſſo and his cotem-
poraries. The French indeed are a forward people,
who pretend to rival all nations of the world in their
ſeveral excellencies; yet conſidering they value
themſelves ſo much on their own academy, it is a
matter of wonder to ſee ſo little improvement in
them by it : And if we are equal only to them now,
how much ſhould we outſhine them, had the Eng-
liſh diſciples in this art as many helps and encourage-
ments as theirs ?

Sir, It is with all poſſible reſpect that I offer you
a treatiſe, which has been finiſhed with ſo many
difficulties. The art was new to us, though the
language of the original was not; but we wanted the
advice of thoſe gentlemen whom Mr Dryden con-
ſulted in his tranſlation of Freſnoy. If we have
erred in terms, you will, I hope, conſider us, as
the world has been favourable to that immortal
poet for the ſame fault. Could I have ſo far pre-
ſumed on your readineſs to oblige all mankind, as
to have deſired to be enlightened by you when I was
in the dark, I had committed fewer errors on my
part, but I had no warrant for that freedom; and
though we communicated the whole work to all
that we believed could aſſiſt us in it, yet it is certain,
with all our caution, we are far from being infalli-
ble.

Several maſters whom I have applied to have dif-
fered about the interpretation of ſome terms; and
even French Painters have aſſured me, that our au-
thor has uſed ſome which were unknown before.
I took the ſenſe of thoſe words from them, and it
agreeing with that of the author, I hope we have no
where

where miftaken him, at leaft confiderably. He is excufable for his innovations, on account of his great knowledge in the art. It was this gentleman who tranflated Monfieur Frefnoy's Latin poem, *De Arte Graphicâ*, and wrote the reflections upon it; but yet not thinking them fufficient to explain it as clearly as he would have it, he publifhed this book twenty years afterwards. He is ftill living in Paris, and defigns and paints very well himfelf for his diverfion, being not of the profeffion; however, I doubt, from the character of the French fchool, whether his practice comes up to his theory.

I am confcious to myfelf, that our tranflation of him, as to the ftile, falls fhort of Mr Dryden's verfion of Frefnoy's poem. The original will, in fome meafure, make amends for that; and it had been happy for our author, and the whole art of Painting, if the gentleman who added the lives of the Painters to Mr Dryden's tranflation, had had leifure or inclination to have done for us what he was fo kind as to do for him, and have fet out the Englifh fchool with the ornaments that his judgment and elegance could have given it. I had his work before me in the execution of my own, and endeavoured to imitate him in the account of thofe Englifh Painters, whom he thought worthy his pen. They had all been immortal in his name and works, whereas I can only expect to have mine preferved by thofe of the Mafters of whom I have written.

Sir, I beg your pardon for troubling you with fo long a ftate of my cafe. I wifh the tranflation and additions ftood lefs in need of your protection, and that I had fome better way of fhewing to the world with what zeal and refpect I am,

S I R,

Your moft humble, and

Moft obedient Servant.

✿✿✿✿✿✿! ✿✿✿✿✿✿✿✿✿✿! ✿✿✿✿✿✿✿✿

*T*HE *Reader will eafily perceive, that though the French author has not vouchfafed to do juftice to the Painters of our nation, yet he has very little to fay of thofe of his own ; and the laft fentence of his book agrees fo ill with his account of the French Painters, and the French tafte, that had not the authors of that nation been the vaineft writers in the world, when they talk of their countrymen, he would not have been guilty of fo ridiculous a flourifh in their favour. The beft of their Painters were much more inferior, in all the parts of the art, to our Van Dyck, than Van Dyck was to Raphael and Titian. In the following pages we fhall prove, that the Englifh Painters and Paintings, both for their number and their merit, have a better claim to the title of a* School, *than thofe of France. But the French would fain thruft themfelves into all the honourable places, as well in the arts and fciences, as in the empire of Europe.*

✿✿✿✿ ✿✿ ✿✿✿! ✿✿✿✿✿! ✿✿ ✿✿✿ ✿✿✿

A N

AN

E S S A Y

TOWARDS AN

ENGLISH SCHOOL

OF

PAINTERS.

A.

Mr *ROBERT AGGAS*,

Commonly called

A U G U S,

 A S a good Englifh landfkip Painter, both in oil and diftemper. He was alfo fkilful in architecture, in which kind he painted many fcenes for the play-houfe in Covent-Garden. There are not many of his pictures extant among us; of thofe that are, the moft confiderable is a piece of landfkip prefented by him to the company of Painter-ftainers, (whereof he was a member) and which now hangs in their hall. He is reckoned

among

among the beft of our Englifh landfkip Painters;
and became eminent, not fo much by his labour and
induftry, as through the bent of his natural genius.
He died in London, in the year 1679, and about
the 60th year of his age.

Mr *H E N R Y A N D E R T O N*

WAS a face Painter, and difciple of Streater,
in great efteem about the year 1665, which
he did not long furvive. He travelled to Rome,
where he ftudied fome years after the antique, and
at his return drew the beautiful dutchefs of Rich-
mond, which recommended him to draw king
Charles II. and moft of his court. He interfered in
his bufinefs with Sir Peter Lely, and had a great
fhare of reputation in thofe times. He was likewife
a landfkip Painter and in ftill life ; as alfo, a good
imitator of his mafter, ferjeant Streater, till he left
his way, and fell to face Painting.

Mr *E D M U N D A S H F I E L D*

WAS a gentleman well defcended, who drew
both in oil and crayons. He was difciple to
Mr Wright, and painted fome heads as big as the
life. He firft found out the way to multiply the
number and variety of tints in crayons, and there-
with to draw various compleations, in imitation of
oil-painting. This he performed on paper, and
practifed feveral years with deferved applaufe. He
brought thofe heads to ten pounds price. From him
the prefent Mr Luttrel had his inftruction, who has
improved that invention, and multiplied the variety
of colours to effect any thing; as alfo found out a
method, unknown before, to draw with thofe chalks
or crayons on copper-plates, either by the life, or
hiftorically.

J O H N

B.

JOHN BAPTIST GASPARS,

Commonly called

L E L Y's B A P T I S T,

WAS born at Antwerp, and brought up in the fchool of Thomas Willeborts Boffaert, a difciple of Vandyck. Coming over into England in the time of the civil wars, major general Lambert took him into his fervice; and upon the happy reftoration of king Charles II. Sir Peter Lely being received for his majefty's principal Painter, he employed Baptift to paint his poftures, which he performed very well, and after his death he did the like for Mr Riley, and afterwards for Sir Godfrey Kneller. This Baptift was a great judge of Painting, and likewife eminent for his defigns for tapeftry, having been an admirable draftfman in the academy. He died in London about fourteen years ago, and lies buried at St James's.

JOHN BAPTIST MONNOYER,

Commonly ftiled the Flower-Painter,

WAS born at Lifle in Flanders, and brought up at Antwerp. His bufinefs there was hiftory-painting; but afterwards he returned to Lifle, and applied himfelf to painting flowers, wherein he fucceeded to admiration. Monfieur le Brun having undertaken the Painting of Verfailles, employed Baptift to do the flower part, wherein he fhewed his excellence, as is yet to be feen in that palace. His grace the duke of Montague being then ambaffador in France, and obferving the curioufnefs

oufnefs of this Painter's work, invited him over
to England, and employed him in conjunction with
meffieurs Roufieau and la Force, to adorn his mag-
nificent houfe in Bloomfbury, where a great variety
of flowers and fruit of this mafter are to be feen,
and thofe the beft of his performance. There are
alfo feveral other pieces of his at my lord Carlifle's,
my lord Burlington's, and other perfons of quali-
ty ; but the moft curious of all, is the looking-
glafs at Kenfington palace, which he painted for the
late queen Mary, of glorious memory, her majef-
ty fitting by him almoft all the while. His flow-
ers have generally in them a loofenefs and freedom
of penciling, together with a luftre of colouring,
which is inimitable. They are alfo of an ordon-
nance very beautiful and furprizing, bearing a good
price fuitable to their great worth, and are eafy to
be diftinguifhed from thofe of other mafters, by
comparing them together, the only way to arrive
at a diftinction of one man's works from another's.
His beft performances are owned to be in England.
He began a vaft collection of fine flower-prints, many
of which were executed by his own hand, and the
reft finifhed by his direction. He died in Eng-
land about ten years ago, and lies buried at St
James's.

Mr *F R A N C I S B A R L O W*,

W AS born in Lincolnfhire, and at his com-
ing to London put apprentice to one Shep-
herd, a face-painter, with whom he lived but few
years, becaufe his fancy did not lie that way, his
genius leading him wholly to drawing of fowl,
fifh, and beafts ; wherein he arrived to that perfec-
tion, that had his colouring and penciling been as
good as his draughts, which were moft exact, he
might have eafily excelled all that went before him
A a 3 in

in that kind of Painting, of which we have an in-
ftance in the fix books of prints after him, now
fold by Mr Tempeft. He drew fome cielings of
birds for noblemen and gentlemen in the country.
There are feveral prints extant after the defigns of
this mafter, among which are the cuts for a new
edition of Efop's fables, in which undertaking he
wanted due encouragement. He alfo drew feveral
of the monuments in Weftminfter-Abby, and in
Henry VII's chapel, which were intended for a large
edition of Mr Keep's Monumenta Weftmonafteri-
enfis. But notwithftanding all Mr Barlow's excel-
lency in his way, and though he had the good for-
tune to have a confiderable fum of money left him
by a friend, he died poor in the year 1702.

Mrs *MARY BEAL,*

WAS an Englifh gentlewoman, born in Suf-
folk, who having learnt the rudiments of
Painting of Sir Peter Lely, drew after the life, and
had great numbers of perfons of good rank fat to
her, efpecially the greateft part of the dignified
clergy of her time; an acquaintance fhe got by her
hufband, who was much in favour with that robe.
She was little inferior to any of her cotemporaries,
either for colouring, ftrength, force or life; info-
much that Sir Peter was greatly taken with her per-
formances, as he would often acknowledge. She
worked with a wonderful body of colours, was ex-
ceedingly induftrious, and her pictures are much
after the Italian manner, which fhe learnt by hav-
ing copied feveral of the great mafters of that coun-
try, whofe pictures fhe borrowed out of Sir Peter's
collection. She died at her houfe in Pallmall about
fix years ago, being 65 years old, and lies buried at
St James's.

ED-

E D W A R D *du* B O I S,

WAS a hiftory and landfkip Painter, but chiefly the latter; and was born at Antwerp. He was difciple to one Groenwegen, a landfkip Painter likewife, who refided many years in England, and had been fome time in Italy. Du Bois alfo travelled to Italy, where he continued eight years; during all which time he ftudied the antiquities, and painted after the Italian gufto, jointly with his brother, a Painter, now living here. He worked fome time in Paris, and in his way to Italy did feveral pieces for Charles Emanuel, duke of Savoy. Soon after his return to Holland, he came to England, and died in London about feven years ago, being 77 years old. He lies buried in St Giles's church. He and his brother, by their extraordinary induftry, have made one of the fineft collections, of clofet pieces efpecially, of any in England.

D A N I E L B O O N,

WAS a Dutch droll Painter, and a great admirer of uglinefs and grimace, both in his fmall and great pictures, in which he feldom forgot to endeavour to raife mirth in his country-men, and ours of the fame fublime genius. He died lately.

J O S E P H B U C K S H O R N,

WAS a Dutch Painter, born at the Hague. who came over to England about the year 1670. He was efpecially eminent for his copies after Sir Peter Lely, whofe manner he came fo near, that feveral heads of his have been miftaken, by good judges, for that great mafter's. He copied

alfo

alfo Vandyck, and the prefent lord Rockingham has the picture of the earl of Strafford done by him, after that great Painter. He was Sir Peter Lely's drapery-painter for many years, and died in London, at the age of thirty-five, being buried in St Martin's church.

B U S T L E R,

WAS a Dutchman, both a hiftory and face Painter, in the reign of Charles II. There is a good picture partly performed by him, in the poffeffion of Mr Elfum of the Temple, which confifts of three boors playing together, in different actions, by Mr Buftler; a good landfkip behind, by Mr Lanckrinck; and a little dog on one fide, by Hondius.

N I C H O L A S B Y E R,

WAS a hiftory and face Painter, born at Dronthem in Norway. He was much employed by the late famous Sir William Temple, at his houfe at Shene, near Richmond in Surry, where he died about twenty or twenty one years ago. He was a Painter of good hopes, but died young, the effect of an intemperate life. He lived with Sir William three or four years, during all which time he was conftantly employed by him, in one fort of Painting or other. One thing is remarkable of him, and that is, that he was the firft man that was buried in St Clements Danes after it was rebuilt, and which had been firft built by his countrymen.

CRXXMB

Mr

C.

Mr *J O H N C A R I N G S,*

WAS an Englifh landfkip-Painter, who lived the better part of his time in Holland, and drew many views of that country in a manner very neat and elaborate. His pieces bore a very great price in his life-time, but having very little befides their neatnefs to recommend them, they have fince been lefs efteemed. He died at Amfterdam above fifty years ago.

Mrs *A N N E C A R L I S L E,*

WAS an Englifh gentlewoman, cotemporary with Vandyck. She copied the Italian mafters fo well, that fhe was much in favour with king Charles I. who became her patron, and prefented her and Sir Anthony Vandyck with as much ultra marine at one time, as coft him above five hundred pounds. She died in London about 26 years ago.

F R E D E R I C C A U S A B O N, alias *K E R S E B O O M,*

WAS born at Solingen, a city of Germany, in the year 1623. At eighteen years of age he went to Amfterdam to be inftructed in the art of Painting, but by whom is uncertain. From thence he removed to Paris in 1650, and worked fome years under monfieur le Brun; but afterwards he was fent to Italy by the chancellor of France, and maintained there by that minifter fourteen years, two whereof he fpent with Nicholas Pouffin, of whofe manner he was fo nice an imitator, that fome of his pieces
have

have been taken for his. Thus qualified for hiftory-painting he came to England; but not finding encouragement here in that way, he bent his ftudies towards portraits, wherein he was not unfuccefsful, either as to drawing or likenefs. He was the firft that brought over the manner of Painting on glafs, (not with a print, as the common way now is) in which he performed fome hiftories and heads exceedingly well. Perfpective he underftood thoroughly, having been difciple to two excellent mafters in that art. He fpoke five languages admirably well, and was, in fhort, an accomplifhed Painter. He died in London in the year 1690, and lies buried in St Andrew's Holborn.

F R A N C I S *de* C L E Y N,

WAS a Dutch Painter, and mafter of the tapeftry works to king Charles I. at Mortlack, for which he painted cartoons in diftemper. He was very eminent for his invention, and made feveral defigns that were extraordinary fine, for painters, gravers, fculptors, &c. among which were the cuts for fome of Ogilby's books. He died at Mortlack a little before the reftoration.

A D A M C O L O N I,

Commonly called the *Old,*

WAS a Dutch Painter, born at Rotterdam, but who refided a great while in England, and became efpecially eminent for his fmall figures in rural pieces, for his cattle, country-wakes, fire-pieces, &c. He alfo copied many pictures of beafts after Baffan, particularly thofe of the royal collection, which are efteemed his beft performances. He died

in

in London in 1685, aged 51, and lies buried in St Martin's church.

HENRY *alias* ADRIAN COLONI,

WAS the fon of the before-mentioned. He was inftructed by his father, and brother-in-law Mr Van Dieft, and became a good drafts-man, as a great number of academy-pieces drawn by him teftify. He often wrought upon the fmall figures in his brother Van Dieft's landfkips; and they received no fmall addition of beauty from what he did, efpecially when he ftrove to imitate the manner of Salvator Rofa. He died young, about the year 1701, at 33 years of age, and lies buried in St Martin's church. He was a perfon of lively invention, and painted very quick.

Mr HENRY COOK,

WAS an Englifh geatleman, and hiftory-Painter, who had his education here, and fome part of it in the univerfity of Cambridge. He was a perfon of good reading, judgment and experience; and after he had travelled fome years in Italy, and been an affiduous copier of the beft mafters, became not only a great critic in Painting, but alfo a good performer, as appears by many public pieces of his, viz. the altar-piece at New-college-chapel in Oxford; what he has done at Chelfea-college, at Hampton-Court, and on many cielings and ftair-cafes of this town and kingdom. His excellent collection of pictures, fold at his death, fpeak his relifh; wherein were many fine copies of the cartoons of Raphael, and after moft of the beft mafters, performed by himfelf. His copies after the cartoons are particularly remarkable, being drawn in turpentine oil, after the manner of diftemper,

of

of which he is faid to be the inventor. He died
in London the 18th of November 1700, aged near
58, and lies buried in St Giles's church.

Mr *ALEXANDER COOPER,*

WAS the elder brother of Samuel Cooper
Efq; and, together with him, brought up
to limning by Mr Hofkins, their uncle. He per-
formed well in miniature; and going beyond fea, be-
came limner to Chriftina queen of Sweden; yet
was far exceeded by his brother Samuel, who was
much the greater mafter. He did likewife landfkip
in water colours exceedingly well, and was account-
ed an extraordinary draftfman.

SAMUEL COOPER Efq;

WAS born in London in the year 1609, and
brought up under his uncle, Mr Hofkins.
He was fo good a performer in miniature, that our
nation may be allowed to boaft of him, having far ex-
ceeded all that went before him in England in that
way, and even equalled the moft famous Italians;
infomuch that he was commonly ftiled the Vandyck
in little, equalling that mafter in his beautiful co-
louring, and agreeable airs of the face, together with
that ftrength, relievo, and noble fpirit; that foft
and tender livelinefs of the flefh, which is inimi-
table. He had alfo a particular talent in the loofe
and gentle management of the hair, which he ne-
ver failed to exprefs well: but though his pencil was
thus admirable, yet his excellency was chiefly con-
fined to a head, for below that part of the body
he was not always fo fuccefsful as could have been
wifhed. The high prices his pieces ftill fell at,
though far fhort of their value, and the great efteem
they are in even at Rome, Venice, and in France,
are

are abundant arguments of their great worth, and
have extended the fame of this mafter throughout
all parts of Europe, where art is valued. He fo far
exceeded his mafter, and uncle, Mr Hofkins, that
he became jealous of him, and finding that the
court was better pleafed with his nephew's per-
formances than with his, he took him in partner
with him; but ftill feeing Mr Cooper's pictures
were more relifhed, he was pleafed to difmifs the
partnerfhip, and fo our artift fet up for himfelf,
carrying moft part of the bufinefs of that time be-
fore him. He drew king Charles II. and his queen,
the dutchefs of Cleveland, the duke of York, and
moft of the court : but the two pieces of his which
were moft efteemed, were thofe of Oliver Cromwel,
and of one Swingfield. The former is now in the
hands of Richard Graham Efq; and by him high-
ly valued. The French king once offered one hun-
dred and fifty pounds for it, yet could not have it.
The other is in the collection of colonel Robert
Child, who fets a great value upon it. This laft
picture Mr Cooper having carried to France, it in-
troduced him into the favour of that court, and
was much admired there. He likewife did feveral
large limnings in an unufual fize, which are yet to
be feen in the queen's clofet, and for which his
widow received a penfion during her life from the
crown. That which brought Mr Cooper to this ex-
cellency, was his living in the time of Vandyck,
many of whofe pictures he copied, and which made
him imitate his ftile. Anfwerable to his abilities in
Painting, was his great fkill in mufic, efpecially
the lute, whereon he was reckoned a mafter. He
was many years abroad, and perfonally acquainted
with moft of the great men in Holland and France,
as well as thofe of his own country ; but he was yet
more univerfal by his works, which were known
throughout all parts of Chriftendom. He died in
London

London in the year 1672, at fixty-three years of age, and lies buried in Pancras church in the fields, where there is a fine marble monument fet over him with the following infcription.

H. S. E.

S Amuel Cooper *Armiger,*
Angliæ Apelles,
Seculi fui, & Artis Decus,
In quâ excolendâ
Sicut Neminem, quem fequeretur, invenit,
Ita nec, qui eum affequatur, eft habiturus.
Supra omne Exemplum,
Simul ac omne Exemplar,
Minio-Graphices Artifex fummus,
Summis Europæ Principibus notus,
Et in Prætio habitus;
Cujus porrò egregias Animi Dotes,
Ingenium expolitiffimum,
Linguarum plurimarum peritiam,
Mores fuaviffimos,
Ut tam brevis Tabella ritè complecti poffet
Ipfius unicè Manu delineanda fuit:
Sed Modeftior ille,
Dum per Ora, Oculofque omnium, Famâ volat,
Cineres hic potiùs fuos optavit delitefcere,
Ipfe, in Ecclefiæ Pace, feliciter requiefcens
Chariffimâ Conjuge Chriftianâ.
Obiit quinto Die Maii, Anno { Ætatis fuæ 63.
{ Salutis MDCLXXII.

Mr *C R O S S,*

W AS a famous copier in the reigns of king Charles I. and II. A ftory goes of him, that being employed by king Charles I. to copy feveral eminent pieces in Italy, and having leave of the ftate of Venice to copy the famed Madonna
of

of Raphael, that was in St Mark's church, he performed the tafk fo admirably well, that he is faid to have put a trick upon the Italians, by leaving his picture for the original, which laft he brought away with that celerity and caution, that though feveral meffengers were fent after him, he had got fo much the ftart of them, that he carried the piece dextroufly off. Afterwards, in Oliver's days, the then Spanifh ambaffador here, Don Alonfo de Cardenes, bought this picture when the king's goods were expofed to fale, together with the twelve Cefars of Titian, and the king Charles on the dun horfe by Vandyck (of which laft there is a good copy by Sir Peter Lely in the Middle-Temple Hall) all which, fome fay, remain in the Efcurial to this day. Though others affirm, the picture of king Charles on the dun horfe, is now in the poffeffion of the duke of Bavaria, who bought it of one Mynheer van Cullen. This Mr Crofs copied likewife, admirably well, Titian's Europa, which picture of his is now in the collection of the earl of Kent.

D.

HENRY and JOHN DANKERS.

HENRY was a good landfkip-Painter, and employed by Charles II. to paint all the feaports in England and Wales; as alfo all the royal palaces; which he performed admirably well. He was firft bred a graver, but upon the perfuafions of his brother John took to Painting. He ftudied fome time in Italy, before he came to England. He worked for great numbers of our nobility and gentry, and had good rates for what he did, being efteemed the neateft and beft Painter, in his way, of that time. He left England in the time of the popifh plot, being a Roman Catholick, and died

soon

foon after at Amſterdam. As for John Dankers, he was a good hiſtory-Painter, and lived for many years after his brother, dying in like manner at Amſterdam.

WILLIAM DERYKE,

WAS a hiſtory-Painter born at Antwerp. He was firſt bred a jeweller, but afterwards took to Painting. He for many years drew hiſtory as big as the life in England, with tolerable ſucceſs. In his works there were many excellent marks of a boldneſs of pencil, whatever there might be wanting in grace, and pleaſing variety. He died about ſeven years ago, leaving behind him a daughter, whom he had inſtructed in his art.

Lord Biſhop DIGBY.

THE reverend lord biſhop of Elfin in Ireland, may very well find a name in this account of the Engliſh Painters, ſince he has deſervedly raiſed one in that kingdom, where he arrived to be a ſpiritual peer. His limnings have much of beauty and juſtneſs of draught in them, and are to a great degree elaborate, with a due regard to the graceful part of nature. He is a ſingle inſtance of any perſon of that dignity, that has made ſo conſiderable a progreſs in this art, as to be voted a maſter, either in that kingdom or this, how common ſoever it is in other nations for the clergy to apply themſelves to Painting.

Mr WILLIAM DOBSON,

WAS a gentleman born in the year 1610, in St Andrew's pariſh in Holborn, and deſcended from a family at that time very eminent in St Albans

bans. He was both a hiftory and face-Painter, be-
ing cotemporary with that great mafter Sir An-
thony Vandyck, whofe excellencies he came very
near, though he failed in fome of his graceful parts;
yet we are to confider he wanted the opportunities
the other had of becoming perfect. The greatnefs
of his genius fhone through the meaner employ-
ments, which were his allotment; being put out ap-
prentice very early to one Mr Peak, a ftationer, and
trader in pictures in the city of London, with whom
he ferved his time; yet had, by his mafter's procure-
ment, the advantage of copying many excellent
pictures, efpecially fome of Titian and Vandyck;
the manner of which two mafters he, in fome mea-
fure, always retained. How much he was behold-
en to the latter of thofe two great men, may eafi-
ly be feen in all his works. He was alfo farther in-
debted to the generofity of Vandyck, for prefent-
ing him to king Charles I. who took him into his
protection, kept him in Oxford all the while his ma-
jefty continued in that city, fat to him feveral times
for his picture, and caufed the prince of Wales,
prince Rupert, and moft of the lords of his court
to do the like. He was a fair middle-fized man,
of a ready wit, and a pleafing converfation, yet be-
ing fomewhat loofe and irregular in his way of liv-
ing, he, notwithftanding the many opportunities
he had of making his fortune, died poor at his
houfe in St Martin's-Lane, in the year 1647, and
the 37th of his age. This is to be remarked of
our artift, that as he had the misfortune to want
fuitable helps in his beginning to apply himfelf to
Painting, fo he wanted alfo due encouragement,
which the unhappy times of civil war could not
afford; yet he fhone out through all thofe difadvan-
tages, which fhews us what he might have been had
Rome been the place of his education. There are
in England feveral hiftory-pieces done by him, of

B b which

which his grace the duke of Buckingham has one
in his collection, of great value. His portraits are
deservedly esteemed among us, to which nature in-
clined him so powerfully, that had his education
been but answerable to his genius, England might
justly have been as proud of her Dobson, as Venice
of her Titian, or Flanders of her Rubens. The
greatest number of his pictures are to be seen in and
about Oxford, where he resided many years.

E.

G E R R A R D E D E M A,

WAS a landskip-Painter, born at Amsterdam,
and disciple of Everdine, whose manner he at
first followed. He came into England about the
year 1670, and became very famous for landskip.
His manner was afterwards broad and bold, in imi-
tation of some Italians. His pictures commonly
afford a scene of cliffs, cascades, and views (as the
learned Dr Burnet in his Theory calls it) of a broken
world. He chose a country uncultivated, full of
rocks, and falls of water; the latter of which he
never failed to express well, dispersing a gentle
warmth throughout the whole, to make amends
for the horror of the prospect, which generally
represents Norway or Newfoundland; places in
which he studied, as Everdine, his master, did be-
fore him; after whom there are many prints, ex-
pressing a country wild and rude. Mr Edema di-
ed at Richmond in Surry, whither he had retired
for the recovery of his health, about the year 1700,
and the 40th year of his age. His too great in-
temperance shortened his days.

Mr

F.

Mr *WILLIAM FAITHORN,*

WAS a difciple to Mr Peak, painter to prince Rupert. After the civil wars broke out he went into the army, when being taken prifoner in Bafing-houfe, and refufing to take the oaths to Oliver, he was banifhed into France, where he ftudied feveral years under Champagne, a famous Painter of that time, and arrived to a very great perfection in correctnefs of drawing. He was alfo a great proficient in graving, as likewife in Painting, efpecially in miniature, of which there are many inftances now in England. He died in Black-Friers about the beginning of king William's reign, and was there buried, being near 75 years of age. His praife was celebrated by his friend Mr Flatman, in the following copy of verfes on his book of drawing, graving and etching.

Should I attempt an elogy, or frame
A paper ftructure to fecure thy name,
The lightning of one cenfure, one ftern frown
Might quickly hazard that, and thy renown.
But this thy book prevents that fruitlefs pain,
One line fpeaks purelier thee, than my beft ftrain.
Thofe myfteries, like to the fpiteful mold
Which keeps the greedy Spaniard from his gold,
Thou doft unfold in ev'ry friendly page,
Kind to the prefent, and fucceeding age.
That hand, whofe curious art prolongs the date
Of frail mortality, and baffles fate
With brafs and fteel, can furely able be
To rear a lafting monument for thee.
For my part I prefer, to guard the dead,
A copper-plate before a fheet of lead.

Se

So long as brass, so long as books endure,
So long as neat-wrought pieces, thou'rt secure.
A Faithorn *sculpsit is a charm can save*
From dull oblivion, and a gaping grave.

Mr *T H O M A S F L A T M A N*,

WAS both a Poet and Painter. He drew in miniature, as may appear by the following stanza in his pindarique ode, called the Review, where he thus speaks of himself as a limner.

To extricate myself from love,
Which I could ill obey, but worse command,
I took my pencils in my hand,
With that artillery for conquest strove ;
Like wise Pigmalion then did I
Myself design my deity ;
Made my own saint, made my own shrine ;
If she did frown one dash could make her smile,
All bickerings one easy stroke could reconcile :
Plato feign'd no Idea so divine.
Thus did I quiet many a froward day,
While in my eyes my soul did play;
Thus did the time, and thus myself beguile ;
Till on a day, but then I knew not why,
A tear fall'n from my eye
Wash'd out my saint, my shrine, my deity :
Prophetic chance ! the lines are gone,
And I must mourn o'er what I doted on :
I find ev'n Giotto's circle has not all perfection.

Now since Mr Flatman's works speak for him in one kind, I will leave the others to do so too, though perhaps limning was his greater excellence. He died in London some few years ago.

Le *F E V R E de V E N I S E,*

WAS a French hiftory-Painter, who came into England in the reign of king Charles II. He was better at defigning, as appears by his works, than at Painting. He had a particular excellence in ftaining marble, which he did feveral times for prince Rupert. He died in London about twenty-nine years ago, and lies buried in St Martin's church.

Mr *J O H N F R E E M A N,*

WAS a good hiftory-Painter in the reign of king Charles II. He was thought to have been poifoned in the Weft Indies, but he returned to England, and died here; yet his genius was fo impaired by that attempt on his life, that his latter works failed of their ufual perfection. He was looked upon as a rival to Mr Fuller, infomuch that his brother, colonel Freeman, offered to lay a wager of one hundred pound that he fhould draw a figure with that mafter; which challenge, for what reafon I know not, was never accepted. Mr Freeman was in his drawings, efpecially in the academy, moft extraordinary, and equal to any of our modern mafters. He was, in his latter days, fcene-Painter to the play-houfe in Covent-Garden, where many of his works are ftill to be feen.

Mr *I S A A C F U L L E R,*

WAS an Englifh hiftory Painter of good note. He had a great genius for drawing and defigning hiftory, which yet he did not always execute with due decency, nor after an hiftorical manner; for he was too much addicted to modernize and

B b 3 burlefque

burlefque his fubjects, there being fometimes a raw-
nefs of colouring in them, befides other extravagan-
cies fuitable to the manners of the man: but not-
withftanding all that a critic may find fault with in
his works, there are many perfections in them, as
may be feen by his Refurrection at All-fouls college
chapel at Oxford, to which that at Magdalen college,
though performed by the fame hand, cannot in the
leaft compare. There is alfo at Wadham college, in
the fame univerfity, an hiftory-piece of his, in two co-
lours only, admirably well performed; for whatever
may be objected againft this mafter, as one that
wanted the regular improvements of travel to con-
fider the antiques, and form a better judgment, he
may be reckoned among the foremoft in an account
of Englifh Painters. He ftudied many years in
France under Perrier, and underftood the anatomical
part of Painting, perhaps equal to Michael Angelo,
following it fo clofe, that he was very apt to make
the mufcelling two ftrong and prominent. Among
his works, there are feveral fine pieces in many great
taverns in London, which are not efteemed the
worft of his performances. He died in London
above thirty years ago.

G.

M A R K G A R R A R D,

SON of Mark Garrard, was born at Bruges in
Flanders. He was fome time principal Painter
to queen Elizabeth, and afterwards to queen Anne,
confort-royal to king James I. He was both a good
hiftory and face Painter, and died at London in the
year 1635, in the 74th year of his age. There are
feveral prints after him now extant among us.

H E N R Y

H E N R Y G A S C A R,

WAS a French face Painter, encouraged here by the dutchefs of Portfmouth, whofe picture he came over to draw. Many following her example, employed him alfo, fo that he got a great deal of money in England in a fhort time; nor could our wife nation then fee the difference between him and his cotemporary Sir Peter Lely. What he wanted in the graceful part, in draught, and a good choice of nature, the talent of but very few, he ufually made up with embroidery, fine cloaths, laced drapery, and a great variety of trumpery, ornaments which took for a while, till at length monfieur found that his gay cap-and-feather manner would no longer fucceed here; which made him leave England about twenty or twenty-five years ago. By a prevailing affurance, cuftomary with his nation, he has fince impofed as much on the Italian nobleffe, as he did on thofe of England; and was lately living at Rome, though we hear he is now dead. He is reported to have carried above ten thoufand pounds out of England.

H O R A T I O G E N T I L E S C H I,

WAS an eminent Italian hiftory Painter, born at Pifa, a city in the dukedom of Tufcany. After having made himfelf famous at Florence, Rome, Genoa, and in moft parts of Italy, he went for Savoy, whence he removed to France; and at laft, upon the invitation of king Charles I. came over to England, and was well received by that king, who appointed him lodgings in his court, gave him a confiderable falary, and employed him in his palace at Greenwich, and other public places. The moft remarkable of his performances in Eng-

land;

land, were the cielings of Greenwich and York-houfe, the latter of which are now in the collection of the prefent duke of Buckingham. He did alfo a Madonna, a Magdalen, and Lot and his two daughters, for king Charles, all which he performed admirably well. The piece of his which was moft efteemed abroad, was the Portico of cardinal Bentivoglio's palace at Rome. He made feveral attempts at face-Painting while in England, but with little fuccefs, his talent lying wholly towards hiftory, with figures as big as the life. He was much in favour with the duke of Buckingham, and many of the nobility of that time; but after twelve years continuance in England, he died here at eighty-four years of age, and lies buried in the queen dowager's chapel at Somerfet-houfe. His print is among the heads of Vandyck, he having been drawn by that great mafter. He left behind him a daughter,

A R T E M I S I A G E N T I L E S C H I,

WHO was but little inferior to her father in hiftories, and even excelled him in portraits; a manner of Painting which moft are inclined to attempt who come to England, where it is chiefly in vogue. She lived the greateft part of her time at Naples in much fplendor, and was as famous all over Europe for her amours as for her Painting. She recommended herfelf to the efteem of the fkilful by many hiftory-pieces as big as the life; among which the moft celebrated was that of David with the head of Goliah in is hand. She drew alfo the portraits of fome of the royal family, and many of the nobility of England.

Mr

Mr *R I C H A R D G I B S O N,*

Commonly called the Dwarf,

WAS difciple of Francis de Cleyn, and an eminent mafter in the time of Sir Peter Lely, to whofe manner he devoted himfelf, and whofe pictures he copied to admiration. Being page to a lady at Mortlack, fhe put him to de Cleyn to learn to draw, which he obferved he had a particular genius to. He had the honour to inftruct in drawing the late queen Mary, when princefs of Orange, and the prefent queen Ann, when princefs ; he went over to Holland to wait on the princefs Mary for that purpofe. He painted both in oil and water colours, but chiefly the latter. He was greatly in favour with king Charles I. (to whom he was page of the backftairs) infomuch that that king gave him his wife in marriage, who is likewife a dwarf, and ftill living, though of a great age. On this wedding, Mr Waller made that copy of verfes which begins thus :

Defign or chance makes others wive,
But nature did this match contrive ;
Eve might as well have Adam fled,
As fhe denied her little bed
To him, for whom Heav'n feem'd to frame,
And meafure out this only dame, &c.

He alfo received confiderable favours from Philip earl of Pembroke, who was his patron. He drew Oliver Cromwel feveral times, and died in Covent-Garden foon after the late revolution, at threefcore and fifteen years of age, lying buried in that church.

Mr

Mr *WILLIAM GIBSON*

WAS nephew to the foregoing, and inftructed both by him and Sir Peter Lely. His greateft excellency lay in his copies after the laft of thofe two mafters, whofe manner he made it his chief endeavour to imitate, and wherein he was not altogether unfuccefsful. He became an eminent limner, and drew great numbers of portraits for many of the beft rank. His great induftry was much to be commended ; for purchafing not only the greateft part of Sir Peter's collection after his death, but likewife for procuring from beyond feas a great variety of valuable things in their kind ; infomuch that he may well be faid to have had the beft collection of drawings and prints, after the greateft Italians and other mafters, of any perfon of his time. He was a great encourager of the art he profeffed. He died of a lethargy in London, and was buried at Richmond in Surrey, in the year 1702, at fifty-eight years of age. His kinfman, Mr Edward Gibfon, was inftructed by him, and firft painted portraits in oil ; but afterwards finding more encouragement in crayons, his genius lying that way, he made a confiderable progrefs therein, till death intervening put a ftop to all his endeavours. He died young, at thirty-three years of age, and lies likewife buried at Richmond.

Mr *JOHN GREENHILL,*

WAS a gentleman defcended from a good family in Salifbury, where he was born. He was difciple to Sir Peter Lely, whofe manner in a fhort time he fuccefsfully imitated, and became a great proficient in crayon draughts, as he afterwards did in Painting. He failed very little of his mafter's excellencies, who firft neglected, and then became

jealous

jealous of him as a dangerous rival; for he never let him fee him paint but once, and that was by a ftratagem. Mr Greenhill had long had a defire to fee Sir Peter manage his pencil, but fo fhy was that great artift of revealing his myftery, that he would never lend him the leaft affiftance all the while he was with him; which made Mr Greenhill, after he had left him, have recourfe to a wile to procure that which he muft otherwife have defpaired of. He procured Sir Peter to paint his wife's picture, through which means he had an opportunity to ftand behind and fee what he did; which being greatly to his fatisfaction, on a double account, he made his mafter a prefent of twelve broad pieces, and fo took the picture away with him. Having thus obtained his end, he in a little time became exceeding famous for face Painting, infomuch that had he not died young, the effect of too free living, England might have boafted of a Painter, who, according to his beginnings, could not have been much inferior to the very beft of foreigners, whom we have always fo much encouraged in the portrait way. He was moreover poetically inclined, and very agreeable in converfation; which won fo much on Mrs Behn, that fhe endeavoured on her part, to perpetuate his memory, by the following elegy.

What doleful cries are thefe that fright my fenfe,
Sad as the groans of dying innocence ?
The killing accents now more near approach,
 And the infectious found
 Spreads, and enlarges all around,
And does all hearts with grief and wonder touch.
 The famous Greenhill's dead ! ev'n he
 That could to us give immortality,
 Is to th' eternal filent groves withdrawn;
Youthful as flowers fcarce blown, whofe op'ning leaves
 A wondrous and a fragrant profpect gives,

 Of

Of what its elder beauties wou'd display,
When it fhou'd flourifh up to rip'ning May.
Witty as poets warm'd with love and wine,
 Yet ftill fpar'd heav'n, and his friend,
For both to him were facred and divine;
 Nor cou'd he this no more than that offend.
Fix'd as a martyr, where he friendfhip paid,
 And gen'rous as a God,
Diftributing his bounties all abroad,
 And foft and gentle as a love-fick maid.

Great mafter of the noblest myftery,
 That ever happy knowledge did infpire;
 Sacred as that of poetry,
And which the wond'ring world does equally admire.
 Great nature's works we do contemn,
 When we on his do meditate;
 The face and eyes more darts receiv'd from him,
 Than all the charms fhe cou'd create;
The difference is his beauties do beget
In the enamour'd foul a virtuous heat,
 Whilft nature's groffer pieces move,
 In the coarfe road of common love.

So bold, yet foft, his touches were;
 So round each part, fo fweet, fo fair,
 That as his pencil mov'd, men thought it preft
 The lively imitated breaft,
 Which yields like clouds where little angels reft:
 The limbs all eafy, as his temper was,
 Strong as his mind and manly too;
 Large as his foul, his fancy was, and new,
And from himfelf he copy'd ev'ry grace;
For he had all that cou'd adorn a face,
 All that cou'd either fex fubdue.

Each

Each excellence he had that youth has in its pride,
 And all experienc'd age can teach,
 At once the vig'rous fire of this,
And every virtue, which that can exprefs,
 In all the height that both cou'd reach;
And yet, alas! in this perfection dy'd,
Droop'd like a bloffom with a northern blaft,
When all the fhatter'd leaves abroad are caft,
 As quick as if his fate had been in hafte.

 So have I feen an unfix'd ftar,
Outfhine the reft of all the num'rous train,
 As bright as that which guides the mariner,
 Dart fwiftly from its darken'd fphere,
And ne'er fhall light the world again.
 Oh, why fhou'd fo much knowledge die,
 Or with his laft kind breath,
 Why cou'd he not to fome one friend bequeath
 The mighty legacy.
 But 'twas a knowledge giv'n to him alone,
 That his eterniz'd name might be
 Admir'd to all pofterity,
By all to whom his grateful name was known.

 Come all ye fofter beauties, come,
 Bring wreaths of flow'rs to deck his tomb;
 Mixt with the difmal cyprefs and the yew,
 For he ftill gave your charms their due;
And from the injuries of age and time,
 Secur'd the fweetnefs of their prime;
And beft knew how t' adore that fweetnefs too.
 Bring all your mournful tributes here,
And let your eyes a filent forrow wear,
Till ev'ry virgin, for a while become
Sad as his fate, and like his picture dumb.

<div align="right">

JOHN

</div>

H.

J O H N H A N N E M A N

WAS both a hiftory and face Painter, born at the Hague. He was difciple to one Ravefteyn, and came into England in the reign of king Charles I. He was employed for fome time under Mytens, principal Painter to that king, and continued here fixteen years, at the end of which he went for Holland, and there drew the princefs dowager royal, his highnefs the prince of Orange, and all the court. He likewife drew a picture, reprefenting peace, in the ftates-chamber at the Hague; as alfo the picture of two ufurers telling their gold, for mynheer van Wenwing. Whilft he was doing this laft piece, he happened to want money, whereupon fending to the perfon he was working for to borrow a fum, it was accordingly fent him. When the picture was finifhed, it was carried home, and the price demanded paid for it; but when mynheer thought to have the money he had lent (having flipped the opportunity of ftopping it out of mere generofity) he was anfwered, that the gold which he had borrowed was all put into the picture (meaning that which the mifers were telling) and that he muft expect no further fatisfaction. This Painter died abroad about twenty years ago.

Mr *J O H N H A Y L E S*

WAS a good face Painter, cotemporary and competitor with Sir Peter Lely. He was fo excellent a copift, that many of the portraits which he did after Vandyck, pafs at this day for originals of that ingenious man. He died in London,

in

in the year 1679, and lies buried in St Martin's
church.

E G B E R T H E M S K I R K

WAS born at Haerlem, and difciple of de
Grebber. He became very eminent for
Painting drolls after the manner of Brawer. His
grofs and comical genius fucceeded for a long while
among us. In moft of his converfations, as he call-
ed them, you may fee the picture, and read the man-
ners of the man at the fame time : but to fpeak of
his Painting part, a thing chiefly aimed at in this
fhort account, there is little fault to be found with
it, unlefs fometimes with the foulnefs of the colour-
ing. His drunken drolls, his wakes, his quakers-
meetings, and fome lewd pieces, have been in vogue
among the waggifh collectors, and the lower rank
of virtuofi. He went in this kind a great way, but
after all fell far fhort of Brawer, Teniers, and the
reft of his noble fore-runners, in the ftudy of fots
paradice. He often introduced his own picture
among his drolls by means of a looking-glafs he had
upon his pallet. He was a man of humour, and for
that valued by the late earl of Rochefter, for whom
he painted feveral pieces. He died in London about
two years ago, leaving behind him a fon whom he
had inftructed in his way.

Mr *N I C H O L A S H I L L I A R D*

WAS a celebrated Englifh limner, who lived
above an hundred years ago. He drew
Mary queen of Scots in water-colours, when fhe
was but eighteen years of age, wherein he fucceeded
to admiration, and gained a general applaufe. He
was both goldfmith, carver, and limner to queen
Elizabeth, whofe picture he drew feveral times, par-
ticularly

ticularly once, when he made a whole length of her, fitting on her throne, which piece was deservedly efteemed. There are, moreover, two beautiful pieces of his, now in the poffeffion of Simon Fan-fhaw, Efq; and by him valued, not without reafon, as it is the opinion of fome good judges, at above fifty guineas each, though not much bigger than a crown-piece. One of thefe is the picture of our artift himfelf, with this infcription in gold letters round it.

Nicolaus Hilliardus Aurifaber, Sculptor, & cele-bris Illuminator Sereniffimæ Reginæ Elifabethæ, Anno 1577. *Ætatis fuis* 30.

The other is the picture of his father, fome time high fheriff of the city and county of Exeter, with this infcription in gold round it.

Richardus Hilliardus quondam Vice-Comes Civita-tis & Comitatus Exoniæ, Anno 1560. *Ætatis fuæ* 58, *Annoq; Domini* 1577.

Thefe two pictures in miniature are fo mafterly done, that not only the faces are finely coloured, and naturally with a good relievo; but alfo the heads and beards are fo well performed, that almoft each fingle hair is expreffed. Now, though thefe two pieces were alone fufficient to preferve the memory of this great artift, yet cannot I omit adding what the famous Dr Donne fays of him, in a poem of his, called the Storm. His words are thefe,

————————*An hand, an eye,*
By Hilliard drawn, is worth an hiftory.

At what time he died, never came to my know-ledge, and fo I hope the reader will excufe that omiffion.

H A N S

H A N S H O L B E I N.

MOnfieur de Piles having given the reader an
account of Holbein's birth and education in
the German fchool, we fhall only relate here fome
things omitted by him, more particularly what con-
cerns him as an Englifh Painter. His manner was
extraordinary and unufual, differing from both that
of the ancients and moderns, fo that it feems as
if he had not been incited or inftructed by any ex-
ample, but rather that he followed purely the dic-
tates of his own genius; and though it be doubted
by fome, whether he ever faw any of the rarities
of Italy, or had any mafter, yet there is nothing
to be feen of his doing but what is painted to the
utmoft perfection. This is manifeft by that piece of
his called Death's Dance, in the Town-hall of Bafle,
the defign whereof he cut neatly in wood, and af-
terwards painted: which appearing wonderful to
the learned Erafmus, he requefted of him to draw
his picture, defiring nothing fo much as to be re-
prefented by fo judicious a hand. This being per-
formed, and Erafmus perceiving by his rare art
that he deferved a more plentiful fortune, he per-
fuaded him to go to England; promifing him
confiderable advantages from the bounty of king
Henry VIII. At his requeft Holbein fet out for this
kingdom, bringing along with him Erafmus's pic-
ture, and letters recommendatory from that great
man, to the then lord chancellor, Sir Thomas More.
Sir Thomas received him with all the joy imagina-
ble, and kept him for three years at his houfe; dur-
ing which time he drew his picture, and thofe of
many of his friends and relations; all which were
hung up in the great hall of that houfe. The king
coming one day, upon an invitation, to dine with
Sir Thomas, and at his entrance into the hall, be-

C c holding

holding fo many ravifhing objects, the pictures
feeming almoft as much alive as the perfons, who
were all there prefent, his majefty fo much admired
the excellency of the Painter, that he next day fent
for him, and entertained him in his fervice upon
very advantageous terms. The king from time to
time manifefted the great efteem and value he had
for him; and upon the death of queen Jane, his
third wife, fent him to Flanders to draw the pic-
ture of the dutchefs dowager of Milan, widow to
Francis Sforza, whom the emperor Charles V. had
recommended to him for a fourth wife; but it be-
ing upon the king's defection from the Roman fee,
he rather chofe to match with a Proteftant princefs,
in hopes by that means to engage the Proteftant
league in Germany in his intereft. Cromwell, his
prime minifter, (Sir Thomas More having been re-
moved and beheaded) propofed Ann of Cleves to
him; but whether the king was diffatisfied with
her having made a fort of pre-contract with the
fon of the duke of Lorrain, or did not approve
her principles, being a Zwinglian, he was not over-
fond of the match, till Cromwell, who had a mind
to effect it to fecure himfelf againft the Papifts
whom he had difobliged, fent over Hans Holbein
to draw her picture likewife; who, as the lord
Herbert of Cherbury fays in his hiftory, was repre-
fented by this artift fo very fine, that when the
king came to fee her portrait; he immediately re-
folved to marry her; though it feems, by the fame
account, that the Painter, perhaps purfuant to the
inftructions he had received from Cromwell, had
followed the beauty of his fancy more than that of
nature, forafmuch as the king was pleafed with
the picture, fo foon as ever he faw the lady he was
difgufted at her, yet he afterwards married her,
that he might not difoblige the princes of Germany.
When Erafmus wrote his Moriæ Encomium, he

fent

fent a copy of it to Hans Holbein, who reading it
was fo pleafed with the feveral defcriptions of fol-
ly, that he defigned all of them in the margin, but
having not room to draw the whole figures, he
pafted a piece of paper to the leaves where he could
not do it ; and when he had done fo, he fent the
book to Erafmus for a prefent. Erafmus feeing he
had drawn the picture of a fat Dutch lover hug-
ging his lafs and his bottle, for the reprefentation of
an amorous fool, wrote under it, Hans Holbein,
and fo returned the book to the Painter ; who, to
be revenged of him, drew the picture of Erafmus
for a mufty groper, that bufied himfelf in fcrap-
ing up old manufcripts and antiquities, and wrote un-
der it Adagia. The original book is in the library
at Bafle ; and monfieur Charles Patin when he re-
fided there, defired leave of the magiftrates to have
the plates of all Holbein's figures engraved, that
he might publifh them in a new edition of Moriæ
Encomium : this edition is the beft of that book,
before which is prefixed the life of Holbein at large
with two prints of him, the one drawn when he
was young, and the other when he was old. Thefe
two prints are very much unlike one another :
there is alfo an account of all his pieces, and in
whofe poffeffion they are. He ufed to paint with
his left hand, and a print of him done by Hollar
is ftill extant, reprefenting him drawing in that
manner. Holbein not only drew the aforefaid pic-
tures, but alfo thofe of Henry VII. and Henry
VIII. on the wall of the palace of White-hall,
which perifhed with it in the late fire. Some endea-
vours were ufed to remove that part of the wall on
which thefe pictures were painted, but all proved
ineffectual. He drew many other pictures in Eng-
land, particularly a large piece of Sir Thomas More,
and his family, which was lately to be feen at Bafils-
Lye houfe in Oxfordfhire; but fome queftion whe-

ther

ther this picture was done all by Holbein or not.
I have seen the following tetrastic upon him, by
a foreigner, which I thought it not improper to
insert.

Egregius pictor magno qui gratus Erasmo,
　His quantum accrevit laus, Basileia, tua?
Divisus nostro te suscipit orbe Britannus
　Holbene, orbe uno laus tua non capitur.

This Painter was as celebrated in miniature, as
he was in oil-colours, and moreover performed a
multitude of designs for gravers, sculptors, jewel-
lers, &c. He lived and died at Whitehall, in those
lodgings which are now the paper-office.

W E N C E S L A U S H O L L A R,

W AS a gentleman born at Prague in Bohemia,
　　in the year 1607. He was by nature much
inclined to miniature and etching, in which last art
he became exceeding famous; though he was not a
little discouraged therein by his father, who would
have had him follow other studies. In the year
1627, he left Prague, and visited many cities in
Germany; when coming at last to Colen, he wait-
ed upon the earl of Arundel, that truly great and
noble patron of arts, who was there on his embassy
to the emperor, to Vienna, and afterwards came
over with him to England. He lived here for some
time, and drew many churches, ruins, persons, and
views, which he afterwards etched, and which will
always be in good esteem: his particular excellency
was etching, and there are great numbers of his
prints in England to do him that justice my pen
must not pretend to. He at last got into the ser-
vice of the duke of York, but upon the breaking
out

out of the civil wars, retired to Antwerp, and there
died.

A B R A H A M H O N D I U S,

W A S born at Rotterdam in the year 1638.
He was a Painter whofe manner was univer-
fal. He drew hiftory, landfkip, cielings, and fmall
figures; but above all the reft, beafts and hunting
pieces were his principal ftudy. In all thefe kinds
his colouring was often extravagant, and his draft
as commonly uncorrect. He delighted much in a
fiery tint, and a harfh way of penciling, fo that
few of his pictures being without this diftinguifhing
mark, his Paintings are eafy to be known. The
dogs and huntings he drew are in good requeft,
though fome of his later performances are carelefs ;
he being, for many years, afflicted with the gout
fo feverely, that he had prodigious fwellings, and
chalk-ftones in moft of his joints, the effects of a
fedentary and irregular life. This diftemper oc-
cafioned his death in London, about the year
1691.

Mr J O H N H O S K I N S,

W A S a very eminent limner in the reign of
king Charles I. whom he drew, with his
queen, and moft of his court. He was bred a face
Painter in oil, but afterwards taking to miniature,
he far exceeded what he did before. He died in
Covent-Garden about forty years ago. He had two
confiderable difciples, who were Alexander and Sa-
muel Cooper, the latter of whom became much the
more eminent limner.

J A M E S

J A M E S H O U S M A N,
alias H U Y S M A N,

WAS a hiftory and face Painter, who refided in England in the time of Sir Peter Lely, and endeavoured to rival him in the portrait way. He was born at Antwerp, and bred up to Painting under one Bakerel, who was brought up with Vandyck in the fchool of Rubens. This Bakerel was not much inferior to Vandyck, as is to be feen in feveral churches of Antwerp, efpecially in that of the Auguftin monks, where Vandyck and he have painted to out-vie each other, and both had commendations in their different ways, though the fuperiority was yielded to neither. But Bakerel, being a Poet as well as a Painter, he wrote a fatire upon the Jefuits, on which account he was forced to take leave of the city of Antwerp ; fo that Houfman having by that means loft his mafter, came for England. Some of his hiftory pieces are well painted, his colouring being bright and fanguine, and in the airs of his faces he out-did moft of his countrymen, who often know better how to perform the Painting part than to choofe the beft life, or execute agreeably any defign. Some Cupids of his were much admired ; but what he valued himfelf moft upon, was the picture of Catherine the queen dowager of England. This picture did him great fervice, fo that he always boafted of that performance, and called himfelf her majefty's Painter. He carried the compliment yet farther, for in all his hiftorical pieces, for a Madonna, a Venus, or any fuitable figure, he always introduced fomething of her refemblance. The moft famous piece of his performance was over the altar of that queen's chapel at St James's, now a French church. He died

in

in London about ten years ago *, and lies buried in
St James's.

C O R N E L I U S *J* O H N S O N, *alias* *J* A N S E N S,

WAS an excellent Painter both in great and
little, but above all his portraits were admi-
rably well performed. He was born in, and refid-
ed a long while at Amfterdam, from whence he
came over to England in the reign of king James I.
and drew feveral fine pictures after that king, and
moft of his court. He alfo lived in the time of
king Charles I. and was cotemporary with Vandyck,
but the greater fame of that mafter foon eclipfed his
merits ; though it muft be owned his pictures had
more of neat finifhing, fmooth Painting, and la-
bour in drapery throughout the whole; yet he want-
ed the true notion of Englifh beauty, and that free-
dom of draught which the other was mafter of.
He died in London.

M A R T I N *J* O H N S O N,

THE famous feal graver, was alfo an extraor-
dinary landfkip Painter after nature. He
was bred, it is true, to graving feals, but painted in
his way equal to any body. He arrived at a great
excellency in landfkip-views, which he ftudied with
application, making a good choice of the delight-
ful profpects of our country for his fubjects, which
he performed with much judgment, freenefs, and
warmth of colouring. Several of his landfkips are
now in the hands of the curious in England, though
they are very fcarce. He died in London about
the beginning of king James the fecond's reign.

* *N. B.* This work was firft publifhed in Englifh in the
Year 1706.

K.

WILLIAM de KEISAR,

WAS a very neat landſkip Painter, after the manner of Elſheimer. He was perfectly of the Dutch goût, minding little particulars more than the whole-together. He wrought ſome time with Mr Loten, the landſkip Painter. He imitated various manners, and drew ſome ſorts of cattle and birds very well. He alſo painted tombs, and ſeveral ſorts of ſtone-work in imitation of Vergazoon. He was not unſkilful in Painting of architecture and flowers. He died in London about ſixteen years ago.

Mrs ANN KILLIGREW,

WAS a young gentlewoman, daughter of Dr Killigrew, maſter of the Savoy, and one of the prebendaries of Weſtminſter. She painted ſeveral hiſtory pieces, as alſo ſome portraits for her diverſion, exceedingly well; as likewiſe ſome pieces of ſtill-life. Mr Becket did her picture in mezzotinto after her own Painting. She was alſo a poeteſs, and wrote a book of poems which were printed. She lived unmarried, and died young about twenty years ago.

Mr JOHN ZACHARY KNELLER,

WAS born at Lubeck, and brother to the preſent Sir Godfrey Kneller. He travelled into Italy, and when he came to England, painted ſeveral portraits in ſmall, very neat. He did alſo ſeveral pieces in ſtill-life exceedingly well. At laſt he took to water-colours, and copied divers of his brother's portraits, in miniature, with good ſucceſs.

He

B. Buckeridge Efq; having written the greateft part of the lives of divers Painters treated of in the E s s a y towards an Englifh fchool, at the requeft of Mr Savage; and having at different times collected from Sir Godfrey Kneller's own mouth the following account of himfelf; he gave it to Mr Platt, for the envoy of Florence, who defired it for the fatisfaction of the Great Duke, to whofe gallery Sir Godfrey had lately prefented his own picture, drawn by himfelf: it was thought proper to infert it here, to do juftice to the fame of fo eminent a genius,

Sir G O D F R E Y K N E L L E R.

HE was born at Lubeck. His grandfather enjoyed an eftate near Hall in Saxony, where he lived in great efteem among feveral princes of Germany, efpecially with count Mansfelt and the bifhop of Hall; to the former of which he was furveyor general of his mines, and infpector of his revenues.

He had one fon by his wife who was of the family of Crowfen, on whom he beftowed a liberal education, fending him for his better improvement in learning to the univerfity of Leipfic, from whence he removed into Sweden, being imployed by queen Eleanor, dowager of the great Guftavus Adolphus. This fon, Zachary Kneller, father of Sir Godfrey, was much favoured by the faid queen until her death; after which he fettled and married at Lubeck, and having ftudied architecture and the mathematics, he obtained from that city a penfion as their chief furveyor.

He

He was no ways wanting in any care or expence in the education of his fon, Sir Godfrey Kneller; whom he fent to Leyden after he was fufficiently inftructed in the Latin tongue, to purfue his ftudies in that univerfity, where he applied himfelf to the mathematics, particularly to fortification; he being at firft defigned for fome military imployment. But his genius leading him ftrongly to drawing figures after the hiftorical manner, he foon made great improvements in it, fo as to be much taken notice of and incouraged. From this city he was removed to Amfterdam, and placed for his better inftruction under the care of Rembrant, the moft famous Painter of that time in Holland: but his fcholar, not contented with that gufto of Painting, where exact defign and true proportion were wanting; his father fent him into Italy at the age of feventeen, and committed him to the care of a near relation. He ftudied at Rome under the favourable influence of Carlo Marat and the Chevalier Bernini, and began to acquire fame in hiftory-Painting, having firft ftudied architecture and anatomy; the latter aptly difpofing him to relifh the antique ftatues, and to improve duly by them. But removing to Venice, he foon found there great marks of civility conferred on him by the Donati, Gartoni, and many other noble families, for whom he drew feveral hiftories, portraits, and family pictures, by which his fame was confiderably increafed in that city: but this could not detain him there. By the importunity of fome friends he was prevailed on to come into England, where his fkill and merit foon made him known; fo that he drew the picture of king Charles II. by the recommendation of the duke of Monmouth more than once, with fuch fuccefs, that his majefty ufed to come and fit for his picture at the houfe where Sir Godfrey dwelt, in the Piazza Covent-Garden. He was fent by this prince into France to
draw

draw the French king's picture, where he had the honour of drawing likewife moft of his royal family, for which he received fome confiderable prefents from that great promoter of arts and fciences; but this did not influence him to ftay long in that kingdom, though it happened at the death of his great patron king Charles II.

At his return he was well received by king James and his queen, and conftantly imployed by them until the grand revolution: after which he continued principal Painter to king William, who diftinguifhed him by the honour of knighthood; neither the king or queen ever fitting to any other perfon; and what is more remarkable, is, that he has had the honour to draw ten crowned heads; four kings of England, and three queens, the Czar of Mufcovy, Charles III. king of Spain, now emperor, when he was in England; and the French king, Lewis XIV. befides divers electors and princes: by which means his reputation became fo univerfal, that the emperor Leopold dignified him as a nobleman and knight of the holy Roman empire, by patent, which he generoufly fent him by count Wratiftan, his embaffador in England, anno 1700. in which there is acknowledgment made of the fervices of his anceftors to the houfe of Auftria. By this patent he is infcribed in the number and fociety of noblemen, with all the privileges of fuch as have enjoyed the fame honour for four defcents, paternal and maternal. The late king William fent Sir Godfrey Kneller to draw the elector of Bavaria's picture at Bruffels; and prefented him with a rich gold chain and medal as a particular mark of the efteem he had for him. From feeing and ftudying many noble works of Rubens, he began to change his ftile and manner of colouring, imitating that great mafter, whom he judged to have come neareft to nature of any other. Moft

of

of the nobility and gentry of England have had
their pictures drawn by him; from which a great
number of mezzotinto prints, and others ingraved
have been made, which speak for him by the high
esteem they are in all over Europe. His draught is
most exact, no Painter ever excelled him in a sure
out-line and graceful disposal of his figures, nor
took a better resemblance of a face, which he sel-
dom failed to express in the most handsom or agree-
able turn of it, and in that likewise which was most
prevailing and to the best advantage; always add-
ing to it a mien and grace suitable to the character,
and peculiar to the person he represented. His ma-
jesty king George I. created him a baronet of Great
Britain. He always lived in the greatest esteem and
reputation; abounding no less in wealth than splen-
dor; in both far surpassing any of his predecessors.
He spent the latter part of his time at Whitton,
near Hampton-Court, where he built a house after
a compleat manner, and furnished it in all respects
accordingly.

His singular humanity and address, and his skill
in music and languages, recommended him to the
friendship and familiarity of many noble persons of
the English nation, particularly to the late duke of
Devonshire, the old earl of Leicester, and the late
earl of Dorset, and to many others still living. Be-
sides the honours already mentioned, Sir Godfrey
Kneller was, out of the great regard paid to him
by the university of Oxford, presented by that learn-
ed body with the degree of doctor of the civil law.
He was also admitted gentleman of the most ho-
nourable privy chamber to king William, queen
Ann, and to his present majesty; and has been in
several reigns honoured with being a deputy lieu-
tenant of the county of Middlesex, and in the com-
mission of peace for that and other counties. The
following lines deserve a place in this account of him.

Kneller

Kneller, whofe hand by power fupreme was taught
To reach the higheft images of thought,
To imitate what gods themfelves had made,
And paint their works in varied light and fhade;
By art ev'n nature to preferve alive,
And make mortality itfelf furvive:
Whofe hand from envious Time catch'd ev'ry grace,
Balk'd his keen fcythe, and fav'd the matchlefs face;
The tree of life held out before the view,
And beauty's paradife wherein it grew,
With all its pleafing charms, its lovelieft features
 drew.
Whofe fkill, not only to the looks confin'd,
Unveil'd to fight the beauties of the mind;
When now h'had finifh'd all this world could fhow,
Whate'er was fair, or great, or good below;
When now his day was done, Kneller is gone,
His fun is fet to rife in worlds unknown:
Though gone to thofe, on earth his afhes lie,
Glorious remains of what could only die:
Whofe fame ne'er can. Whofe works fhall ever raife
His own, the nobleft monument of praife.

His pictures in public places.

KING William on a white horfe, at Hampton-
 Court.
The celebrated beauties of his time, there alfo.
The king of Spain, now emperor, at Windfor.
A Chinefe convert, there; a whole length.
The duke of Glocefter, at the lower houfe, there.
King George at Guildhall, London.
Dr Wallis, and his own picture, at Oxford.
 His

His own ſtair-caſe at Whitton, moſt part of it drawn
by himſelf, the reſt by la Guerre.

A family piece for the duke of Buckingham.

Queen Ann, and the duke of Gloceſter.

The kitt-catt club, at Mr Tonſon's ſeat at Barn.
Elms.

Sir Iſaac Newton.

Lady Mary Wortley Mountague.

L.

Major-General *L A M B E R T*,

WAS a great encourager of Painting, and a
good performer in flowers, as is yet to be ſeen
in the duke of Leeds's houſe at Wimbleton. It is
probable he might have learnt this art, or at leaſt
been furthered in it by Baptiſt Gaſpars, whom he
received into his ſervice at his coming to England,
in the time of the civil wars. His eldeſt ſon John
Lambert Eſq; painted alſo faces for his diverſion
very well, of whom many pictures are ſtill to be
ſeen. This laſt gentleman died about four years
ago, at his eſtate in Yorkſhire.

P R O S P E R H E N R I C U S L A N C K R I N C K,

WAS of German extraction, and as near as can
be gueſſed, born in the year 1628. His fa-
ther being a ſoldier of fortune, came with his wife
and only ſon (this Proſper) into the Netherlands,
and that country being then embroiled in war, pro-
cured a colonel's command, which he enjoyed not
many years, dying a natural death at Antwerp. His
widow being a diſcreet women, ſo managed her
ſmall fortune, as to maintain herſelf ſuitable to her
huſband's quality, and give her ſon liberal educa-
tion,

tion, defigning him for a monaftery; but his young-
er years difcovering a natural genius to Painting,
by his continual fcrawling on paper, fhe was oblig-
ed to comply therewith, though with the greateft re-
luctancy, and put him to a Painter. Now, though
he may be fuppofed to have learnt of this perfon
the rudiments of his art, yet the city-academy of
Antwerp was his chiefeft preceptor. His advances
in the fcience were prodigious, and his natural ge-
nius being for liberty, led him to that delightful
branch of Painting, landfkip, wherein he had the
advantage of mynheer Van Lyan's collection,
which was very large, and full of curious pieces of
all the eminent mafters of Europe. Mr Lanckrinck
made his principal ftudy after the pictures of Ti-
tian and Salvator Rofa; and for his great fkill was
foon taken notice of by the curious. His mother
dying, he came to his fortune young; and being
admired for his performances, refolved to come to
England; where he met with a reception fuitable to
his great merit. Sir Edward Sprag, that noble
fea-commander, being a great lover of Painting,
became his patron, recommending him to feveral
perfons of quality, and the virtuofi of that time;
among whom was Sir William Williams, whofe
houfe was finely adorned with this mafter's pic-
tures, but was not long after moft unfortu-
nately burnt; fo that of this great Painter there
are now but very few finifhed pieces remaining; he
having beftowed the greateft part of his time, while
in England, on that gentleman's houfe. He was
alfo much courted by Sir Peter Lely, who employ-
ed him in painting the grounds, landfkips, flow-
ers, ornaments, and fometimes the draperies of
thofe pictures he intended to gain efteem by. As
to his performances in landfkip only, they were
wonderful, both as to the invention, harmony,

<div align="right">colouring</div>

colouring and warmth; but above all furprizingly
beautiful and free in their fkies, which by general
confent excelled all the works of the moſt eminent
Painters in that kind. This may appear by fome
pieces of his, yet to be feen in the cuſtody of thofe
curious lovers of art, Mr Henly, Mr Trevour and
Mr Auſten, the father of which laſt was his great
friend and patron. His views are generally broken,
rude and uncommon, having in them fome glar-
ings of light well underſtood, and warmly painted.
The only cieling I know of his painting, was at
Richard Cent's Efq; at Caufham in Wiltfhire,
near Bath, which is worth feeing. He practifed
moreover drawing after the life, and fucceeded well
in fmall figures, which were a great ornament to
his landfkips, and wherein he imitated the manner
of Titian. Mr Lanckrinck being of a debonnair
temper, had a numerous acquaintance, among
whom was Mr Robert Hewit, who being a great
lover of Painting, at his death left behind him a
large and noble collection of pictures. Our artiſt
was not only a good bottle-companion, and excel-
lent company, but alfo a great favourite of the la-
dies, through his complaifance and comely appear-
ance. But amidſt all thefe delights, little of the lat-
ter part of his life was employed in Painting, they
being believed to have much fhortened his days, for
he died in his middle age in Auguſt 1692. No one
of his time gave greater teſtimony of a true love to,
and a great knowledge in Painting than Mr Lanck-
rinck; witnefs his noble and well-chofen collection
of pictures, drawings, prints, antique heads, and
models, that he left behind him, moſt of which he
brought from beyond fea.

Mr *L A N I E R,*

WAS a Painter well fkilled in the Italian hands. He was employed by king Charles I. beyond fea, to purchafe that collection made by him, the firft Prince we ever had that promoted Painting in England, to whom he was clofet-keeper. He gave a particular mark, by which we diftinguifh all the things of this kind which he brought over. By reafon of the troubles that enfued, we can give no account of his death, but that before he died, he had the mortification to fee that royal collection difperfed.

MARCELIUS LAURON, or LAROON,

WAS born at the Hague in the year 1653, and firft brought up under his father, who was a face and landfkip Painter. Afterwards he was put to a hiftory Painter at the Hague, with whom he ftaid not long. Then, being very young, he came over with his father to England, where he was once more placed with a Painter, one La Zoon, whom not having any great opinion of, he was turned over to Mr Flefheer, with whom he ferved his time. When he came to work for himfelf, he made it his endeavour to follow nature very clofe, fo that his manner was wholly his own. He was a general Painter, and imitated other mafters hands exactly well. He painted well, both in great and little, and was an exact draftfman; but he was chiefly famous for drapery, wherein he exceeded moft of his cotemporaries. He was likewife famed for pictures in little, commonly called converfation-pieces. There are feveral prints extant after this mafter, both in mezzotinto and engraving. He died of a confumption, about the

D d age

age of 52, at Richmond in Surrey, where he lies
buried.

Sir *P E T E R L E L Y*,

WAS born in Weftphalia in Germany, in the
year 1617. He was bred up for fome time
at the Hague, and afterwards committed to the care
of one De Grebber. Coming over to England in
the year 1641, he for fome time followed the natu-
ral bent of his genius, and painted landfkip with
fmall figures, as likewife hiftorical compofitions; but
at length finding face Painting more encouraged
here, he turned his ftudy that way, wherein, in a
fhort time, he fucceeded fo well that he furpaffed all
his cotemporaries in Europe. In his younger days
he was very defirous to finifh the courfe of his ftu-
dies in Italy, but being hindered from going thither
by the great bufinefs he was perpetually involved in,
he refolved to make himfelf amends, by getting the
beft drawings, prints and Paintings of the moft cele-
brated Italian hands. This he fet about fo induftri-
oufly that at length he obtained what he fought af-
ter, and may well be faid to have had the beft cho-
fen collection, of any of his time. Among thefe
we muft reckon the better part of the Arundel col-
lection, which he had from that family, many of
the drawings whereof were fold at prodigious rates
at his death, bearing upon them his ufual mark of
P. L. What advantage he had from this expedient,
may fufficiently appear by that wonderful ftile in
Painting which he acquired by his daily converfing
with the works of thofe great men. In his correct
draft, and beautiful colouring, but more efpecially
in the graceful airs of his heads, and the pleafing va-
riety of his poftures, together with the gentle and
loofe management of the draperies, he excelled moft
of his predeceffors, and will be a lafting pattern to
 all

all fucceeding artifts. However, the critics fay he preferred almoft in all his faces a languifhing air, long eyes, and a drowzy fweetnefs peculiar to himfelf, for which they reckon him a mannerift, and that he retained a little of the greenifh caft in his complexions, not eafily forgetting the colours he had ufed in his landfkips; which laft fault, how true foever at firft, it is well known he left off in his latter days. But whatever of this kind may be objected againft this great Painter, it is certain his works are in great efteem abroad, as well as here, and they are both equally valued and envied; for, at that time, no country exceeded his perfections, as the various beauties of that age reprefented by his hand, fufficiently evince. He frequently did the landfkips in his own pictures, ofter a different manner from all others, and better than moft men could do. He was likewife a good hiftory-Painter, as many pieces now among us can fhow. His crayon-drafts are alfo admirable, and thofe are commonly reckoned the moft valuable of his pieces, which were all done entirely by his own hand, without any other affiftance. Philip earl of Pembroke, then Lord chamberlain, recommended him to king Charles I. whofe picture he drew, when prifoner at Hampton-court. He was alfo much favoured by king Charles II. who made him his principal Painter, knighted him, and would frequently converfe with him as a perfon of good natural parts and acquired knowledge; fo that it is hard to determine whether we was the more compleat Painter or gentleman. He was well known to, and much refpected by the people of the greateft eminence in the kingdom. Becoming enamoured of a beautiful Englifh lady, he after fome time married her. His eftate and family ftill remain at Cue, in the county of Surrey, a place to which he often retired in the latter part of his life. This great artift died of an apoplexy in London, in the year 1680,

and

and in the 63d year of his age. There is a marble
monument with his buft raifed for him in Covent-
Garden church, where he lies buried, whereof the
carving was performed by Mr Gibbons, and the
epitaph written, as it is faid, by Mr Flatman. A
copy of the latter is as follows:

> *Hic fitus eft Petrus Lelius,*
> *In Angliâ Famâ & Divitiis crevit ;*
> *Primus fcilicet in Arte Pictoria Magifter,*
> *Ille Secundus erit qui felicius imitabitur.*
> *Mirè Tabellas animavit, quibus Prætium*
> *Longe hinc diffita ftatuent Secula ;*
> *Ipfe interim digniffimus cui Statua decernatur,*
> *Quâ ejus in feros Nepotes referatur Gloria.*

Obiit Novembris 30 *Die, Anno.* { *Ætatis fuæ* 63. *Sa-*
{ *lutis,* Mdclxxx.

> *Proh Dolor ! ut cujus Penicillo tanta Venuftas,*
> *Reddit adhuc Vivos tot poft fua Funera Vultus ;*
> *Ipfe Cadaver iners, & tetro Pulvere miftus*
> *Nunc jaceat. Cum fe primo fubduxerat Unus*
> *Lelius, innumeri furgunt de Gente Minorum*
> *Pictores, aufi fragiles tentare colores :*
> *Sic poftquam occubuit Sol Aureus, Aftra repentè*
> *Mille fuos pandunt Cœli Laquearibus Ignes,*
> *Quanquam Mille licet vix Umbram Unius adæquant,*
> *Petre Vale, nunquam meritò te Laude fequemur,*
> *Majorem Invidiâ ; neque noftro Carmine vivos*
> *Ni te Gibbonius Spirantem in Marmore fingat.*

B A L T H A Z A R van L E M E N S.

WAS a hiftory Painter of a good family in
Flanders, and born at Antwerp. His fmall
pieces of hiftory are very pleafing and well coloured.
His manner was free, and often very graceful. His
misfortunes

misfortunes in the latter part of his life, wherein he was often in trouble, might very well give a check to his fancy, which made him proftitute his pencil to every undertaking that produced prefent profit; fo that it is no wonder if many of his latter performances were really very much below himfelf. His drawings and fketches are excellent, and by fome thought much better than many of his finifhed pieces. He died in London, in the year 1704.

Mr *WILLIAM LIGHTFOOT*,

WAS a good Englifh Painter in perfpective, architecture and landfkip. He began in diftemper, but afterwards took to oil Painting. He was concerned in contriving and adorning fome part of the royal exhange. He died in London about thirty-five years ago.

JOHN LOTEN,

WAS a Hollander, and a landfkip Painter. He lived and painted many years here, in a manner very fylvan, like the glades and ridings of our parks in England. He is, for the moft part, very cold in his colouring, which is mixed with an unpleafant darknefs; however, he underftood well the difpofition of lights and fhadows. He delighted particularly in oaken trees, which he almoft every where introduced into his pictures. His landfkips are generally very large. He did many ftorms at land, accompanied with fhowers of rain, tearing up of trees, dafhings of water and water-falls, cattle running to fhelter, and the like, which he had a particular genius to, and excellence in. Thefe pieces were admirably good. He painted alfo many views of the Alps in Switzerland, where he lived feveral years. His works abound among us, fo that it is

eafy

eafy to be feen whether this character of him be juft
or not. He died in London about twenty-five
years ago.

M.

Mr *T H O M A S M A N B Y,*

W AS a ftood Englifh landfkip Painter, who
had been feveral times in Italy, and confe-
quently painted much after the Italian manner. He
was famous for bringing over a good collection of
pictures, which were fold at the banqueting-houfe
about the latter end of king Charles IId's reign. He
died in London about fourteen or fifteen years ago.

D A N I E L M Y T E N S,

W AS a Dutch portrait Painter in king James,
and king Charles Ift's time. He painted
the pictures of thofe two kings, the latter of which
is now in the poffeffion of the prefent lord treafurer.
Some of his pictures have been taken for Vandyck's,
whofe manner he imitated. His head is alfo to be
feen among thofe of that great mafter, who painted
his picture. He had a penfion from king Charles I.
being his majefty's principal Painter; and upon
Vandyck's arrival in England, though he loft his
place, yet his penfion was continued to his death.

O.

Mr *I S A A C O L I V E R,*

W AS a very famous limner, who flourifhed
about the latter end of the reign of Queen
Elizabeth. He was eminent both for hiftory and
faces, many pieces of which were in the poffeffion
of

of the late duke of Norfolk ; and being a very good defigner, his drawings were finifhed to a mighty perfection, fome of them being admirable copies after Parmegiano, &c. He received fome light in that art from Frederico Zucchero, who came into England in that reign. He was very neat and curious in his limnings, as may be feen from feveral hiftory-pieces of his in the queen's clofet. He was likewife a very good Painter in little. He died between fifty and threefcore, in king Charles Ift's time, and was buried in Black-Friers, where there was a monument fet up for him with his bufto, all which has been fince deftroyed by fire. I have feen a print of him with this Latin infcription under it ;

ISAACUS OLIVERUS ANGLUS, Pictor.

Ad vivum lætos qui pingis Imagine Vultus,
 Olivere, Oculos mirifice hi capiunt.
Corpora quæ Formas jufto hæc expreffa Colore
 Multum eft, cum Rebus convenit ipfe Color.

Mr *P E T E R O L I V E R*

WAS fon of the before-mentioned, who had inftructed him in his art. He became exceeding eminent in minature, infomuch that he outdid his father in portraits. He drew king James I. prince Henry, prince Charles, and moft of the court at that time. He lived to near threefcore, and was buried in the fame place with his father, about the year 1664.

Mr

P.

Mr *HENRY PAERT,*

WAS firſt diſciple of Barlow, and afterwards of Stone, the famous copier. He was brought up a ſcholar, and ſpent ſome time at one of our univerſities. He painted under Mr Stone ſeveral years, but afterwards fell to Painting faces by the life, yet his talent ſeemed to be for copying. He copied with great aſſiduity in the greateſt part of the hiſtory-pieces of the royal collection in Eng-land, and in ſeveral of them he had good ſucceſs. What he ſeemed to want was a warmth and beauty of colouring. He died in London about the year 1697 or 1698.

Mr *THOMAS PEMBROKE,*

WAS both a hiſtory and a face Painter, and diſ-ciple of Laroon, whoſe manner he imitated. He painted ſeveral pictures for the Earl of Bath, in conjunction with one Mr Woodfield, a diſciple of Fuller, and now living. He died in London in the 28th year of his age, and about twenty years ſince.

JACOB PEN,

WAS a Dutch hiſtory Painter in the reign of king Charles II. He was excellent both in drawing, colouring and compoſition, and died in London about twenty years ago.

Mr *EDWARD PIERCE,*

WAS a good hiſtory and landſkip Painter, in the reigns of king Charles I. and II. He alſo
drew

drew architecture, perfpective, &c. and was much
efteemed in his time. Little of his work now re-
mains, the far greater part having been deftroyed
by the dreadful fire in 1666. It chiefly confifted of
altar-pieces, cielings of churches, and the like; of
which laft fort there is one yet remaining done by
him in Covent-Garden church, where are to be found
many admirable parts of a good pencil. He worked
fome time for Vandyck, and feveral pieces of his
performance are to be feen at Belvoir-caftle in Lei-
cefterfhire, the noble feat of the duke of Rutland.
He died in London about forty years ago, leaving
behind him three fons, who all became famous in
their different ways. One was a moft excellent car-
ver in ftone, as appears by a noble marble vafe of
his doing at Hampton-court. There is a fine head
of Mr Pierce, the father, in Mr Seamer the gold-
fmith's poffeffion, which was painted by Dobfon.

Mr *FRANCIS le PIPER*,

WAS the fon of a Kentifh gentleman, de-
fcended from a Walloon family. His fa-
ther having a plentiful eftate, gave this, his eldeft
fon, a liberal education, and would have had him
apply himfelf to the ftudies of learning, or have
been a merchant; but his genius leading him whol-
ly to defigning he could not fix to any particular
fcience or bufinefs, befides the art to which he na-
turally inclined. Drawing took up all his time,
and all his thoughts; and being of a gay, facetious
humour, his manner was humorous or comical.
He delighted in drawing ugly faces, and had a ta-
lent fo particular for it, that he would, by a tran-
fient view of any remarkable face of man or wo-
man that he met in the ftreet, retain the likenefs
fo exact in his memory, that when he expreffed it in
the draught, the fpectator, who knew the origi-
nal,

nal, would have thought the perfon had fat feveral times for it. It is faid of him, that he would fteal a face; and a man that was not handfome enough to defire to fee his picture, fat in danger in his company. He had a fancy peculiar to himfelf in his travels: he would often go away, and let his friends know nothing of his departure; make the tour of France, and the Netherlands a-foot, and fometimes his frolic carried him as far as Grand Cairo: he never advifed his friends and relations of his return, any more than he gave them notice of his intended abfence; which he did, to furprize them alternately with forrow and joy. By this means, at feveral times he travelled through part of Italy, part of France, Spain, Germany, the Netherlands and Holland. The greateft curiofities that he fought after were the works of the Painters which he examined every where with pleafure and judgment, and formed to himfelf a manner of defign, which no man, in that kind, ever excelled, and perhaps ever equalled. Having a good eftate of his own, and being generous, as moft men of genius are, he would never take any thing for his drawings. He drew them commonly over a bottle, which he loved fo well, that he fpent great part of his hours of pleafure in a tavern. This was the occafion, that fome of his beft pieces, efpecially fuch as are as large as the life, are in thofe houfes, particularly at Mr Holms's the Mitre Tavern in Stocks-Market, where there is a room called the Amfterdam, which is adorned with his pictures in black and white. The room takes its name from his pieces, which reprefenting a Jefuit, a Quaker preaching, and fome other preachers of moft religions, that were liable to be expofed, was called the Amfterdam, as containing an image of almoft as many religions as are profeffed in that free city. The two moft remarkable pieces are the Jefuit and the

Quaker,

Quaker, wherein the differing paffions of thefe two fects are fo admirably well expreffed, that there appears no want of colours to render them lively and perfect. He drew alfo other merry pieces for one Mr Shepherd a vintner, at the Bell in Weftminfter, which Mr Holms purchafed to make his collection of this mafter's pieces the more complete, and the benefit of fhewing them has not been a little advantageous to his houfe. Mr le Piper drew another famous droll-piece, reprefenting a conftable, with his mirmidons, in very natural and diverting poftures. He feldom defigned after the life, and neglected the part of colouring; but yet he fometimes, though very rarely, coloured fome of his pieces; and, as we are informed, was not very unfuccefsful in it. He was a great admirer and imitator of Auguftine Caracci, Rembrant, Van Rhine's, and Hemfkirk's manner of defign, and was always in raptures when he fpoke of Titian's colouring; for notwithftanding he never had application enough to make himfelf mafter of that part of his art, he always admired it in thofe that were, efpecially the Italians. He drew the pictures of feveral of his friends in black and white, and maintained a character of truth, which fhewed, that if he had thought fit to beftow fo much time, as was neceffary to perfect himfelf in colouring, he would have rivalled the beft of our portrait Painters in their reputations. Towards the latter end of his life, having brought his circumftances into a narrower compafs than he found them on his father's death, he fometimes took money. He drew fome defigns for Mr Ifaac Becket, who performed them in mezzotinto. Thofe draughts were generally done at a tavern; and, whenever he pleafed, he could draw enough in half an hour to furnifh a week's work for Becket. His invention was fruitful, and his drawing bold and true. He underftood landfkip Painting, and per-
formed

formed in it to perfection. He was particularly a
great mafter in perfpective. In defigning of his
landfkips he had a manner peculiar to himfelf. He
always carried a long book about with him, like a
mufic book, which, when he had a mind to draw,
he opened, and looking through it, made the lower
corner of the middle of the book his point of fight,
by which, when he had formed his view, directed
his perfpective, and finifhed his picture. His hand
was ready, his ftrokes bold; and, in his etching,
fhort. He etched feveral things himfelf, generally
on oval filver plates for his friends, who being, moft
of them, as hearty lovers of the bottle as himfelf,
they put them to thofe ufes that were moft ferviceable
to them over their glaffes, and made lids with
them for their tobacco-boxes. He drew feveral of
the Grand Signiors heads for Sir Paul Rycaut's hif-
tory of the Turks, which were engraved by Mr
Elder. In the latter part of his life he applied
himfelf to the ftudy and practice of modelling in
wax, in baffo relievo, in which manner he did a-
bundance of things with good fuccefs. He often
faid, " he wifhed he had thought of it fooner, for
" that fort of work fuited better with his genius
" than any." Had he lived longer, he would have
arrived to a great perfection in it. Being one time
at a tavern with Mr Faithorn, Mr Sturt the gra-
ver, and others, he fketched a head with a coal on
a trencher, and gave it to Mr Faithorn, who touch-
ed upon it; in the mean time Mr le Piper drew
another on another trencher, and exchanged it with
Mr Faithorn for that which he had touched. They
did thus ten times, and between them wrought up
the heads to fuch a height of force, that nothing
could be better done in the kind. Thefe trenchers
are ftill extant, but we could not hear in whofe
hands they are at prefent. Some time before his
death another eftate fell to him, by the deceafe of
his

his mother, when giving himself a new liberty, on the enlarging his fortune, he fell into a fever by his free way of living, and making use of an ignorant surgeon to let him blood, the fellow pricked an artery, which accident proved mortal. He was very fat and corpulent, and that might contribute to the misfortune that happened to him in being let blood: but however heavy his body was, his mind was always sprightly and gay. He was never out of humour nor dull, and had he borrowed more time from his mirth to give to his studies, he had certainly been an honour to his country. He died in Aldermanbury about eight years ago, yet lives still in the memory of his acquaintance with the character of an accomplished gentleman, and a great master in his art. His pieces are scattered up and down, chiefly in this city, and the best, and most of them, are in the hands of Mr le Piper, his brother, a merchant of London. His corps was carried from Christ-Church hospital, to the church of St Mary Magdalen Bermondsey in Southwark, where it was buried in a vault belonging to his family.

R.

REMIGIUS van LEMPUT,
alias REMEE,

WAS a famous copier in the reign of king Charles II. of the neat masters, as Stone was of the great Italians. He was a native of Antwerp, and a great copier of Vandyck, by whom he was much encouraged. His pieces sometimes, through the advantage of time upon them, pass for that great master's, now age has a little embrowned the tint, softned the colouring, and perhaps concealed some part of the stifness, whereof he stands accused by the critics. He had one hundred and fifty pound

for

for copying Henry VII. and Henry VIII. in one
piece after Holbein, being the famous picture that
was on the wall at Whitehall, which was afterwards
burnt. He was very famous for the beft collection
of drawings and prints of any of his time. It was
he that bought the celebrated piece of king Charles I.
on horfeback by Vandyck, now at Hampton-Court,
for a fmall matter in the time of the troubles, which
carrying over to Antwerp, he was there bid one
thoufand guineas for it, and ftood for one thoufand
five hundred; but thinking that not enough, he
brought it over to England again, where the times
being turned, he ftill infifting on the fame fum, he
had the picture taken from him by due courfe of
law, after it had coft him a great deal of money
to defend. He died in London about thirty years
ago.

J O H N R I L E Y Efq;

WAS born in London in the year 1646. He
was an excellent Englifh portrait Painter,
who arrived to his great fkill in that province,
through the inftruction of Mr Zouft, an extraordi-
nary Dutch mafter, of whofe manner he retained
much, though perhaps with him he wanted the
choiceft notions of beauty; but for the part of
face-Painting, few have exceeded him of any nation
whatfoever. Had not the gout, that enemy to the
fedentary and ftudious, carried him off, we might
have oppofed a Riley to a Venetian Bombelli, or to
all that the French academy has produced, in that
manner of Painting, to this day. His fame rofe
from the death of Sir Peter Lely, at which time he
was recommended to the favour of King Charles II.
by Mr Chiffinch, whofe picture he drew. He was
afterwards employed in drawing fome of the king's
children, and at laft his majefty fat to him himfelf.

He

He alfo drew king James II. and his queen, and king William and queen Mary upon the revolution, when he was fworn their majefty's Painter. He was very diligent in the imitation of nature, and ftudying the life rather than any particular manner ; by which means he attained a pleafant and moft agreeable ftile of Painting. His excellence was confined to a head, a great number of which do him juftice, even in the beft collections of our nation. He was modeft and courteous in his behaviour, and of an engaging converfation. He died in the year 1691, at 45 years of age, and lies buried in Bifhopsgate church.

PETER ROESTRATEN,

WAS born at Haerlem, and difciple of Frans Hals, whofe manner he at firft followed, but afterwards falling into ftill-life, and having performed an extraordinary piece, that Sir Peter Lely fhewed to king Charles, and which his majefty approved, he was encouraged to purfue that way; which he continued to his dying day. He was an excellent mafter in that kind of Painting, viz. in gold and filver plate, gems, fhells, mufical inftruments, &c. to all which he gave an unufual luftre in his colouring, and for which his pictures bear a good price. It is faid, that one day promifing to fhew a friend a whole-length of his mafter Frans Hals, and through a little delay, his friend growing impatient to fee it, he fuddenly called up his wife (his mafter's daughter, whom he had married) and told him fhe was a whole-length of that mafter. He died laft fummer was three years in James ftreet, Covent-Garden, and lies buried in that church.

Mrs

Mrs *S U S A N N A H P E N E L O P E* ROSE,

WIFE to Mr Rofe the jeweller, now living, and daughter to Mr Richard Gibfon the dwarf, before-mentioned, by whom fhe was inftructed in water-colours, and wherein fhe performed to admiration. She not only copied finely, but alfo drew exceedingly well after the life in little. She died about fix years ago, at forty-eight years of age, and lies buried in Covent-Garden church.

J A M E S R O U S S E A U,

WAS a French landfkip-Painter, born at Paris. He had great part of his inftruction from Harman van Swanevelt, who married a relation of his. He afterwards travelled to Italy, where he ftudied fome years, and perfected himfelf in architecture, perfpective and landfkip, by following the manner of the moft eminent Painters in that kind, and ftudying the antiquities. Returning to Paris, he was wholly employed, for fome years, by the king at Marly, and elfewhere ; but leaving that fervice upon the perfecution, he retired to Switzerland, from whence he was invited to return by monfieur Louvois chief minifter of ftate, upon all the promifes of indemnity imaginable, to finifh what he had begun ; which, refufing to do, he notwithftanding made a prefent to the king of his draughts and defigns for that purpofe, and moreover nominated a perfon to perform the work. After a little ftay in Switzerland he came for Holland, from whence he was invited over to England by the duke of Montague, who employed him at his ftately houfe in Bloomfbury. Upon his coming over hither, he farther
ther

ther improved himself in the study of landskip, and added beautiful groups of trees to the many drafts he made after nature, in several parts of this king-dom. His views are commonly sylvan and solid, his waters of all kinds, well understood and tranf-parent, his fore-grounds great, and generally well broke; and in a word, the whole very agreeable and harmonious. His skill in architecture made him often introduce buildings into his landskips; as he did also small figures, after the manner of Pouf-fin. Many of his pictures may be seen at Hampton-Court over the doors; but far greater numbers are at the duke of Montague's in Bloomsbury; where, in conjunction with La Fosse and Baptift the flower-Painter, he did the ftair-cafe and many other parts of that magnificent fabric. He had all due encou-ragement from that noble peer, who allowed him a pension during life; which, however, lasted but few years after the finishing of his grace's house.

When we speak of Painters, we commonly mean what relates to the performance of their art, and that we have chiefly confined ourselves to in this account; but in treating of this person, we might lay a better scene before us of many instances of hu-manity joined with his pious and charitable acts, especially that at his death, in bequeathing almost all he had to his poor suffering brethren of the Pro-teftant persuasion here in England. He executed with his own hand several prints in aqua fortis after his own landskips, from whence we may form an idea of this master's works. These plates are now in the possession of Mr Cooper, the print-seller. He died in London about the year 1694.

E e *GASPAR*

S.

G A S P A R S M I T Z,

Better known by the name of

M A G D A L E N S M I T H,

WAS a Dutch Painter, who came over to England about twenty-five years ago. He practised his profession some time in London; but afterwards upon the encouragement of a lady of quality, whom he had instructed in his art, and from whom he received a considerable pension, he waited on her ladyship over to Ireland, where he gained the greatest esteem, and had very large prices for his work. He painted portraits in oil of a small size; but his inclination led him most to drawing of Magdalens, from whence he had his name, and whereof he drew a great number by a certain English gentlewoman, who passed for his wife. These Magdalens were very gracefully disposed, and beautifully coloured, expressive of the character of grief and penitence, and the whole-together handsomly ordered. Mr Smitz had moreover a particular talent for painting fruit and flowers; insomuch that one bunch of grapes of his performance was sold in Ireland for forty pounds sterling. He seldom failed to introduce a thistle in the fore-ground of his Magdalens, which he painted after nature with wonderful neatness. He instructed with good success several scholars, who have since made a considerable proficiency in the art; but though he got a great deal of money by these and other means, yet through his irregular way of living, he died poor in Dublin about the year 1689.

Mr

Mr *T H O M A S S T E V E N S O N,*

WAS bred up under Aggas, and became a good Painter, not only in landfkip, but alfo in figures, and architecture in diftemper. He was efpecially eminent for fcene-painting, though his works are not fo much in efteem now as when he was alive.

Mr *J O H N S T O N E,*

WAS an extraordinary copier in the reigns of King Charles I, and II. He was bred up under Crofs; and having the advantage of being an exquifite draftfman, he performed feveral admirable copies, after many good pictures in England. He did a great number of them, and they are reckoned among the beft of the Englifh copies. He did alfo fome imitations after fuch mafters as he more particularly fancied, which performances of his are ftill had in great repute, and received into the beft collections among us. He fpent thirty feven years abroad in the ftudy of his art, where he improved himfelf in feveral languages, he being a man of learning. He died in London the 24th of Auguft, 1653, and lies buried in St Martin's.

P E T E R S T O O P,

WAS a Dutch battle-Painter, who came into England from Portugal, with the late Queen-dowager. His chief ftudy was battles, huntings and havens, which he performed for fome time with good fuccefs; but after the arrival of John Wyke into England, who painted in the fame way, his pictures were not fo much valued, by reafon of the greater excellency of that mafter.

This

This Stoop etched feveral prints of horfes, as like-
wife the Queen-dowager's public entry. He died
here about the year 1686.

Mr *R O B E R T S T R E A T E R*,

WAS born in the year 1624, and bred up to
Painting and Defigning under du Moulin.
Being a perfon of great induftry, as well as capa-
city, he arrived at eminence in divers branches of
his art, efpecially in hiftory, architecture and per-
fpective, wherein he excelled all of his time in
England, and fhewed himfelf a great mafter by the
truth of his out-lines, and the method of fore-
fhortning his figures, as may be feen by his works.
His chief excellence was in landfkip, having a great
freedom of penciling with equal invention, and was
moreover remarkable for ftill-life ; infomuch that
there are fome fruit of his Painting yet to be feen,
which are of the higheft Italian gufto, both for pen-
ciling, judgment and compofition. To do him but
common juftice, he was the greateft and moft uni-
verfal Painter that ever England bred ; which we
owe, in fome meafure, to his reading, he being re-
puted a very good hiftorian, which no doubt con-
tributed not a little to his perfection in that way of
Painting. He had alfo a very good collection of
Italian books, drawings and prints, after the beft
mafters, was always very diligent in drawing in the
academy, and this even in his latter days for the
encouragement of youth ; and, in a word, he may
well be efteemed the moft compleat draftfman of
his time. Upon the happy reftoration of King
Charles II. he was made his majefty's Serjeant-pain-
ter, his merit having recommended him to that
prince, who was a judge of Painting, and confe-
quently knew how to reward it. At length, by
continual ftudy and affiduity, he became fo afflict-
ed

ed with the ftone, that it made the latter part of his
life uneafy to him ; infomuch that to get rid of his
pains, which were moft intolerable, he refolved to
be cut ; which King Charles hearing of, and having
a great kindnefs for him, he fent on purpofe to
France for a furgeon, who came over and perform-
ed the operation. Though he did not die under it,
he furvived it but a fhort time ; for it was, in great
meafure, the caufe of his death, in the year 1680,
at fifty-fix years of age, after he had lived in great
efteem and reputation all his days. His principal
works were at the theatre at Oxford, fome cielings
at Whitehall, which are now burnt ; the battle of
the giants with the gods, at Sir Robert Clayton's ;
the pictures of Mofes and Aaron, at St Michael's
church in Cornhill ; all the ancient and fine fcenes
in the old play-houfe, and many other pieces of
equal value and confideration, which I have not
room to infert.

J O H N S Y B R E C H T,

W AS a landfkip-Painter, born at Antwerp in
Brabant, and brought up in that city under
his father. He was a clofe imitator of nature in all
his landfkips. In his younger days he went upon the
Rhine, and other adjacent places, where he drew
feveral pleafant views in water-colours; fo that he
fpent more of his life that way than he did in Paint-
ing: for which reafon his drawings were more valu-
ed than his pictures. The occafion of his coming
hither was this : the duke of Buckingham, in his way
home from his embaffy in France, paffing through
the Netherlands, ftaid fome time at Antwerp, where
meeting with feveral of this mafter's works in land-
fkip, he was fo well pleafed with them, that he in-
vited him over to England, and promifed to make
him his Painter in that way ; which upon his coming

over he performed; and he did a great number of
thofe pictures for him at Cliveden-houfe: However,
after three or four years ftay with him, he left him,
and performed feveral pieces for the nobility and
gentry of England, among whom he was for fome
time in vogue. He alfo drew feveral forts of cattle
with good fuccefs, which he commonly placed in
his landfkips. He died about the year 1703, in
London, and lies buried in St James's church, be-
ing feventy-three years of age.

T.

Mr *HENRY TILSON,*

WAS an Englifh face-Painter of good note, born
in London. After he had been inftructed for
fome time by Sir Peter Lely, in the nature of face-
Painting he travelled for Italy, where he ftaid fix
or feven years, and during that time copied with
wonderful care and exactnefs a great number of
pictures of the beft mafters; by which means, at his
return to England, he became not a little famous in
the portrait-way : and was much more acceptable to
the curious in his art than he was to a miftrefs, whom
he had courted for a long time, till at length through
a melancholy habit of body, contracted by her un-
kindnefs, and a fedentary life, he fhot himfelf with
a piftol. He had a particular genius for crayons, in
which he performed admirably well, after the pic-
tures of Corregio, Titian, and the Caracci, while
he was at Rome. He died at 36 years of age, and
lies buried at St Clement's.

HENRY

V.

HENRY VANDERBORCHT,

WAS born at Frankendale in the Palatinate, and ftudied under his father, of the fame name. By reafon of the wars breaking out, he was removed to Frankfort in the year 1636; when the Earl of Arundel paffing by that way in his embaffy to the emperor, he took him along with him to Vienna, from whence he fent him to Italy to collect what rarities he could procure there for him. At his return he brought him over to England, and he continued with him to the Earl's death; upon whofe deceafe he was preferred to the fervice of the Prince of Wales, afterwards King Charles II. when after having lived a confiderable time at London in great efteem, he returned to Antwerp, where he died. His father was likewife very much valued by the earl of Arundel for his fine collection of rarities and antique curiofities.

JOHN VANDER-HEYDON,

WAS a good face-Painter, and a native of Bruffels. Coming over to England, he worked for Sir Peter Lely in his draperies and copying, feveral years; till afterwards marrying, he went into Northamptonfhire, and was employed by moft of the nobility and gentry of that county. There are feveral of his pictures to be feen in thofe parts, efpecially at the earl of Gainfborough's, my lord Sherrand's, and at Belvoir caftle. He died about the year 1697, at my lord Sherrand's, and lies buried at Staplefort in Leicefterfhire.

A D R I A N V A N-D I E S T,

WAS a famed landſkip-Painter, born at the Hague, but whom we may very well term an Engliſh Painter, having been brought up here from his youth. He was chiefly inſtructed by his father, who commonly drew ſea-pieces; but that which contributed moſt to make the ſon a maſter, as he often owned, was drawing after thoſe noble views of England in the weſtern parts, and along our coaſts. He alſo drew many of the ruined caſtles in Devonſhire and Cornwall; being encouraged by that noble peer the earl of Bath, at his ſeat in thoſe parts. This Painter's diſtances have a peculiar tenderneſs, and his clouds a freedom that few have arrived at. Had he lived in Italy, or been more encouraged here in the ſtudy of his beſt manner, he might have equaled the greateſt landſkip-Painters either of our own, or other nations; but the loſs of his legs early by the gout, and the low prices for which he painted afterwards, checked his fancy, and made him leſs careful in his deſigns, which on ſome occaſions would be good imitations of Salvator Roſa and Bartholomeo. He began a ſet of prints after ſome very good drafts done by him from landſkip views, but before he could finiſh them, he ended an afflicted life in the year 1704, and the forty-ninth of his age; and lies buried in St Martin's church.

Sir *A N T H O N Y V A N D Y C K,*

HAD his firſt inſtructions from Henry Vanbalen of Antwerp; but having ſeen the more admirable works of Rubens, he left Vanbalen to follow that great maſter, whom he judged more worthy his imitation. Rubens, charmed with his wit, concealed nothing from him that was neceſſary to poliſh

lifh and make him a fkilful artift, being far from en-
vying or feeking to nip his glory in the bud, as many
others would have done. Whilft he lived with this
mafter, there happened a paffage which not a little
contributed to his reputation: Rubens having left a
picture unfinifhed one night, and going out, con-
trary to cuftom, his difciples made ufe of that op-
portunity to fport and play about the room; when
one, more unfortunate than the reft, ftriking at his
companion with a maul-ftick, chanced to throw
down the picture, which receiving fome damage, as
not being dry, the young men were not a little a-
larmed at it, well knowing how very angry their
mafter would be when he came to find his work
fpoiled. This made them ufe their beft endeavours
to fet things right again; but finding all ineffectual,
they had recourfe, as their laft remedy, to Vandyck,
who was then working in the next room, entreating
him by all means that he would touch up the pic-
ture anew. He complied with their requeft, and
having touched up the piece left it upon the eafel.
Rubens, coming next morning to his work again,
firft ftood at a diftance to view his picture, as is
ufual with Painters, and having contemplated it a
little, fuddenly cried out, he liked his piece far bet-
ter than the night before, the occafion of which be-
ing afterwards talked of, it not a little redounded
to the honour of Vandyck, and encreafed his efteem
with his mafter. Whilft he lived with Rubens, he
painted a great number of faces, and among the reft
that of his mafter's wife, which is efteemed one of
the beft pictures in the Low Countries. He painted
two more admirable pieces for his mafter, one repre-
fenting the feizing of our Saviour in the garden,
and the other the crowning him with thorns. Af-
ter having finifhed thefe too fine pictures, he tra-
velled to Italy to fee Titian's works, and at his re-
turn made that incomparable piece for the monaftery
<div align="right">of</div>

of the Auguftins at Antwerp, confifting of St Au-
ftin looking up ftedfaftly to heaven, which appears
all open and fhining with light. The prince of
Orange hearing of his fame, fent for him to draw
his princefs and childrens pictures, which he per-
formed to admiration. No fooner had thefe rare
pieces been feen in public, but the moft confider-
able perfons in Holland were ambitious to be drawn
by the fame hand. The nobility of England and
France fent likewife on purpofe for this curious artift,
that they might partake of the fame happinefs ; but
fo numerous were they, that Vandyck not being
able, with his utmoft induftry, to content them all,
drew only thofe he had the moft refpect for, who
gratified him accordingly. Being arrived in Eng-
land, he was prefented to King Charles I. by Sir
Kenelm Digby, when the King not only knighted
him as a peculiar mark of his efteem, but alfo made
him a prefent of a maffy gold chain with his picture
fet round with diamonds, and befides fettled a con-
fiderable penfion upon him. He was a perfon of
low ftature, but well proportioned; very handfome,
modeft, and extremely obliging; and moreover a
great encourager of all thofe of his country who
excelled in any art, moft of whofe pictures he drew
with his own hand, and which were engraven after
him by the beft gravers of that time, (as Bolfwaert,
Vorfterman, Pontius, &c.) and fome were etched by
himfelf. He married one of the faireft and nobleft
ladies of the Englifh court, daughter of the lord
Ruthven, earl of Gowry, whofe father being ac-
cufed of a confpiracy againft K. James I. his eftate
was confifcated; fo that he had no great portion with
his wife, except her beauty and quality. He al-
ways went magnificently dreffed, had a numerous
and gallant equipage, and kept fo good a table in
his apartment, that few princes were more vifited,

or better ferved. Towards the latter end of his life, growing weary of face-Painting, and being defirous to immortalize his name by fome more glorious undertaking, he went for Paris, in hopes to be employed in the great gallery of the Louvre; but not fucceeding there, he returned to England again; and, by his friend Sir Kenelm Digby, propofed to the King to make cartoons for the banqueting-houfe at Whitehall, the fubject of which was to have been the inftitution of the order of the Garter, the proceffion of the knights in their habits, and the ceremony of their inftallment, with St George's feaft: but his demand of 80,000 l. being judged unreafonable, whilft the king was treating with him for a lefs fum, the gout, and other diftempers, put an end to his life. He was buried in St Paul's church, and if any monument was fet up for him, it was deftroyed afterwards by the fire.

WILLIAM VANDERVELDE,

Commonly called *the Old,*

WAS an extraordinary fhip-Painter of Amfterdam. Coming over into England, he was much employed by King Charles II. for whom he painted feveral of the fea-fights between the Dutch and Englifh. He alfo underftood navigation admirably well, and is faid to have conducted the Englifh fleet to the burning of Schelling. He was the Father of a living mafter, whom no age has equalled in fhip-Painting, and this we owe to the father's inftructions, who was an admirable draftfman of all maritime objects. He lived at Greenwich, to be the more converfant in thefe things, which were his continual ftudy; and in which King Charles II. and King James II. gave him all poffible encouragement, making him their Painter, with a confiderable fa-
lary,

lary, which was afterwards continued to his fon, now living, 1706. The father, in his latter days, commonly drew in black and white, on a ground prepared on canvas, but which appeared like paper. He gave an eafy freedom to his fails and tackle, as alfo to every part of a fhip due proportion with infinite neatnefs. For his better information in this way of Painting, he had a model of the mafts and tackle of a fhip always before him, to that nicety and exactnefs, that nothing was wanting in it, nor nothing unproportionable. This model is ftill in the hands of his fon. Old Vandervelde died in London about the beginning of King William's reign.

F R A N C I S V A N Z O O N,

WAS an eminent Dutch Painter of fruit, flowers and plants. He was bred up at Antwerp under his father, old Van-zoon, a Painter in the fame way. Having married a niece of ferjeant Streater's, fhe brought him into the bufinefs of feveral perfons of quality, which firft occafioned his being known. He painted loofe and free, yet kept clofe to nature, and all his pictures feem drawn by the life. He began fome large pieces, wherein he propofed to draw all the phyfical plants in the apothecaries garden at Chelfea, but which work proving tedious, he defifted from it, having greater encouragement other ways. He died here in London about the year 1702, and lies buried at St James's.

H A R M A N V A R E L S T,

WAS elder brother of the famous Simon Varelft, now living. He painted hiftory, fruit and flowers, after a very agreeable manner, and well coloured. He educated feveral fons and one daughter in the fame way of drawing, moft of whom are ftill living.

living. This artift ftudied fome time at Rome, and refided a while in the emperor's court at Vienna, which, city he left, upon the Turks coming before it in 1683. He died at London about the year 1699, and lies buried in St Andrew's Holborn.

H E N R Y V E R G A Z O O N,

WAS a Dutch Painter of landfkip and ruins, but chiefly the latter, which he performed exceeding neatly. His colouring was very natural, but his landfkip part commonly too dark and gloomy, appearing as if it was drawn for a night-piece. He fometimes painted fmall portraits, which were very curious. Vergazoon left England fome time ago, and died lately in France.

F. de V O R S T E R M A N,

WAS difciple of Harman Sachtleven, and an extraordinary curious and neat landfkip Painter in little, in which he may very juftly be faid to have exceeded all the Painters of his time. He performed his landfkips with wonderful care and neatnefs, after the Dutch goût ; fparing no pains in his views, which commonly reprefent places on the Rhine, where he had ftudied, and accuftomed himfelf to take in a large extent of hills and diftance. The extravagant prices he demanded for his pictures, hindered him from being often employed by King Charles II. who was pleafed with his manner of Painting, efpecially that piece he made of Windfor-caftle, now extant in the royal collection. He accompanied Sir William Soams, fent by King James II. on an embaffy to Conftantinople, but upon that minifter's death he returned to France, and died there. His defign in going for Turky was to draw all the remarkable views in that empire; but he was difappointed by his patron's death, without whofe

pro-

protection he durſt not attempt it, to the great regret of all lovers of art.

W.

Mr. *R O B E R T W A L K E R,*

WAS an Engliſh face-Painter, cotemporary with Vandyck, and whoſe works, by the life, beſt ſpeak their own praiſes. He lived in Oliver Cromwell's days, and drew the portraits of that uſurper, and almoſt all his officers, both by ſea and land. The great duke of Tuſcany bought an original of Oliver by this maſter, in this manner; having ſent over an agent here to purchaſe Oliver's picture for him, the perſon could light on none to his mind for a long while, till at length hearing of a woman, a relation of the uſurper's, that had one, he went to ſee it, and found it in all reſpects ſo well performed, that he bid her a good price for it. She not wanting money, told him, ſince ſhe had the honour to be related to the protector, ſhe would by no means part with his picture; but the gentleman ſtill inſiſting upon having it, and deſiring her to ſet what price ſhe pleaſed upon it, ſhe thinking to get rid of his importunity by her exorbitant demand, aſked him 500 l. for it; when, contrary to her expectation, he had no ſooner heard the ſum named but he told her ſhe ſhould have it, and accordingly paid down the money immediately, which, ſhe being bound by her word to take, parted with her picture even with regret, though at ſo great a rate. This is to be underſtood to have happened in the protector's lifetime. Mr Walker alſo painted Oliver Cromwel, and major-general Lambert, both in one piece, which picture is now in the poſſeſſion of the earl of Bradford. His own picture, drawn by himſelf, now hangs in the founder's gallery, near the public library

library in Oxford. He died a little before the re-
ftoration.

Mr *PARREY WALTON*,

WAS an Englifh Painter, and difciple of
Walker. He painted ftill-life very well,
but his particular excellence lay in knowing and dif-
covering the hands of other artifts. He was well
verfed in Italian pictures, and had the care of the
royal collection. Walton was alfo remarkable for
mending the works of many of the great mafters
that had fuffered either by age or ill ufage, and
this he did by feveral of the beft pictures at White-
hall. He died in London about the year 1699.

Mr *WILLIAM WISSING*,

WAS a face-Painter, bred up under Dodaens,
an hiftory-Painter, at the Hague. Upon his
coming over to England, he worked fome time for Sir
Peter Lely, whofe manner he fuccefsfully imitated;
after whofe death he became famous. He painted
King Charles II. and his Queen, King James II. and
his Queen, the prince and princefs of Denmark; and
was fent over to Holland, by the late King James,
to draw the prince and princefs of Orange, all which
he performed with applaufe. What recommended
him to the efteem of King Charles, was his pictures
of the duke of Monmouth, whom he drew feveral
times, and in feveral poftures. He drew moft of
the great men of the court; and was competitor
with Sir Godfrey Kneller, who was at that time upon
his rife. Mr Wiffing's good manners and com-
plaifance recommended him to moft peoples efteem.
In drawing his portraits, efpecially thofe of the fair
fex, he always took the beautiful likenefs; and when
any lady came to fit to him, whofe complexion was
any

any ways pale, he would commonly take her by the
hand, and dance her about the room till fhe became
warmer, by which means he heightened her natural
beauty, and made her fit to be reprefented by his
hand. He died much lamented, at the age of thir-
ty-one, at the late Earl of Exeter's (Burleigh-houfe
in Northamptonfhire) and lies buried in Stamford
church, where that noble peer erected a monument
for him, with the following infcription :

Quem Batava Tellus educavit,
Gallia aliquando fovit,
Anglia cumulatioribus beneficiis profecuta eft,
Artium, quas varias callebat, juftior Æftimatrix.
Vir facillimis & fuaviffimis Moribus,
Inter Florem & Robur Juventæ,
Vix Trigefimum Secundum Vitæ Annum ingreffus,
Willielmus Wiffingus Hagenfis,

H. S. E.

Pictor Antiquis Par, Hodiernis Major ;
Lelii celeberrimi non degener Difcipulus.
Heu Fatum præcocis Ingenii !
Quam fubitô decerpitur Botrus,
Quia Cæteris feftinantius maturefcit :
Cujus ad confervandam Memoriam,
Munificentiffimus Joannes Comes Exceftrenfis,
Patronorum Optimus,

P. M. P. C.

Obiit 10. *Die Sept. An.* 1687.

There is a Metzotinto print of him, under which
are thefe words ;

Gulielmus Wiffingus, inter Pictores, fui Seculi Cele-
berrimos, nulli fecundus ; Artis fuæ non exiguum
Decus & Ornamentum.
Immodicis brevis eft Ætas ——

F R A N C I S

FRANCIS WOUTERS,

WAS born at Lyere, in the year 1614, and bred up in the school of Rubens. He was a good Painter of figures in small, chiefly nakeds; as also of landskips. His merit promoted him to be principal Painter to the emperor Ferdinand II. and afterwards coming into England with that Emperor's embassador, he was, upon the death of that prince, made gentleman of the bed-chamber, and chief Painter to King Charles II. then prince of Wales. He lived a considerable time at London in great esteem, and at length retiring to Antwerp, died there.

Mr *MICHAEL WRIGHT,*

WAS an English portrait Painter, born of Scots parents. He painted the judges in Guildhall, which pieces of his are deservedly in good esteem. He also drew a Highland laird in his proper habit, and an Irish Tory in his country dress; both which whole-lengths were in so great repute at the time when they were done, that many copies were made after them. Mr Wright's manner of Painting was peculiar to himself. He was well versed in Paintings and drawings of almost all masters. He was likewise well skilled in statuary, and had a considerable collection of antique medals, of which he was an excellent judge. In his latter days, he waited on my Lord Castlemain, in his embassy to Rome, and was his lordship's Major-domo. Returning to England, he died in London about the year 1700.

THOMAS

T H O M A S van W Y K E.

Commonly called *the Old,*

WAS father of John van Wyke, a famous Painter, born at Haerlem. He painted land-fkips, efpecially havens and fea-forts, fhipping and fmall figures ; but his particular excellency lay in reprefenting chymifts in their laboratories, and things of like nature. He followed the manner of Peter de Laer, alias Bamboccio. He left England, and lived abroad a confiderable time, but died here about the year 1686.

J O H N van W Y K E,

SON of the beforementioned, was a Dutch battle-Painter of great note. He has both in his horfes and landfkips, a great freedom of penciling and good colour; as alfo a great deal of fire in moft of his defigns, fome of which are very large, efpe-cially thofe of fieges and pitched battles, as thofe of Namur, the Boyne, &c. His hunting-pieces are alfo in great efteem among our country gentry, for whom he often drew horfes and dogs by the life, in which he imitated the manner of Woverman. He died at Mortlack, where he had lived for fome time, about the year 1702.

Z.

Mr *Z O U S T,* or *S O E S T,*

WAS an eminent Dutch face Painter, who came into England about fifty years ago, and found here encouragement fuitable to his merit. His portraits of men are admirable, having in them

a

a juft, bold draft, and good colouring; but he did not always execute with a due regard to grace, in womens faces; which is an habit can only be acquired by drawing after the moft perfect beauties, in which his country did not greatly abound. What we are moft indebted to him for, is his educating Mr Riley, of whom I have fpoken elfewhere at large, and therefore fhall not need to repeat any thing here. Mr Zouft painted a great many people of quality. His colouring was very warm, and he was a good imitator of nature; but, for the moft part, unfortunate in his choice. He died in London about the year 1676.

F I N I S.

Sir *JAMES THORNHILL*,

THE son of a gentleman of an ancient family and estate in Dorsetshire, was born in the year 1676. His father's ill conduct having reduced him to sell his estate, the son was under the necessity of seeking for a profession that might support him. Young Thornhill came to London, where his uncle Sydenham the famous physician, supplied him with the necessary assistances for studying under a middling Painter, whose limited talents being of little use to his disciple, he trusted to his own judgment and application; genius and taste supplying the place of a master, by the strength of which he made a surprizing progress in the enchanting art of Painting.

He travelled through Holland and Flanders, from whence he went into France, where he bought several good pictures; amongst others, a Virgin of Annibal Carrache, and the history of Tancred, by Poussin. If he had seen Italy, his works would have had more delicacy and correctness. His only view in travelling seemed to be acquiring a knowledge of the tastes of different nations, and buying up good pictures, in which he was very curious.

Thornhill's merit soon spread his character, and raised his reputation to the highest pitch. Queen Ann appointed him to paint in the dome of St Paul's, the history of that saint, which he executed in a grand and beautiful manner on eight pannels, in two colours relieved with gold.

Her

Her majefty alfo nominated him her firft hiftory Painter. He afterwards executed feveral publick works; particularly at Hampton-Court, where he painted an apartment, wherein the queen and prince George of Denmark her hufband are reprefented allegorically; as alfo another piece painted intirely on the wall, where the fame fubject is treated in a different manner. The other parts of the Paintings there are done by Antonio Verrio the Neapolitan.

Thefe great works having eftablifhed his reputation, procured him much employment among people of quality and fortune.

His mafter-piece is the refectory and faloon of the failors Hofpital at Greenwich. The paffage to this refectory is through a veftibule, where Sir James has reprefented in two colours the winds in the cupola, and on the walls boys who fuftain pannels to receive the infcription of the names of the benefactors: From thence you afcend into the refectory, which is a fine gallery very lofty, in the middle of which king William III. and queen Mary his wife, are allegorically reprefented fitting and attended by the Virtues, and Love, who fupports the fceptre. The monarch appears giving peace to Europe; the twelve figns of the Zodiack furround the great oval in which he is painted; the four feafons are feen above; laftly, Apollo, drawn by his four horfes, making his tour through the zodiack.

This Painter has reprefented in the angles the four elements, and the Coloffal figures that fupport the baluftrade, where the portraits of thofe able mathematicians, that have perfected the art of navigation, are painted; fuch as Ticho Brahé, Copernicus, and Newton. The ceiling is all by his own hand, but he employed a Polander to affift him in painting the walls, which he has adorned with thofe Virtues that are fuitable to the intention of the fabrick; fuch as Liberality, Hofpitality and Charity. The faloon above is
not

not fo beautiful as the cieling, you afcend to it by feveral fteps.

The cieling reprefents queen Ann and prince George of Denmark, furrounded with heroic Virtues; Neptune and his train bringing their marine prefents, and the four quarters of the world prefenting themfelves in divers attitudes to admire them. The late king George I. is painted on the wall facing the entry, fitting with all his family around him. On the left hand is the landing of king William the III. prince of Orange, afterwards king of England; on the right, that of king George the firft at Greenwich. Thefe great works would have been certainly more efteemed, if they had all been by Sir James Thornhill's own hand: They are entirely from his defigns, but one cannot help in looking at them criticizing their incorrectnefs; one would even wifh there were fewer figures. Thefe works difplay a true genius in their author, and a great judgment and knowledge in treating the allegory; talents which muft neceffarily produce great and rich compofitions.

As Sir James had acquired a confiderable fortune, he laid out part of it profitably, in buying back the eftates his father had fold, and in rebuilding a beautiful houfe, where he ufed to live in fummer time. He was knighted by king George II. but by the iniquity of the times, he had the honour to be turned out from his publick employment, in company with the great Sir Chriftopher Wren, to make room for perfons of far inferior abilities, to the reproach of thofe who procured their difcharge; after which, to amufe himfelf, he did not leave off Painting eafil pictures. The ill treatment he met with, was thought to have impaired his health; at laft, after a year's ficknefs, he died in the country in 1732, at the age of 56, in the fame place where he was born. By his marriage he left a fon and daughter.

This

This Painter was well made, and of an agreeable humour. He was feveral years chofen member of parliament; and was alfo chofen fellow of the Royal Society of London, which admits eminent artifts into its body, as well as men of learning. He defigned a great deal from practice, with a great facility of pencil. His genius, fo well turned for hiftory and allegory, was no lefs fo for Portrait, Landfkip, and Architecture; he even practifed the laft fcience as a man of bufinefs, having built feveral houfes.

He had a fine collection of defigns of great mafters, which he had collected with diligence, and which did honour to his tafte; thefe he fhewed very readily to ftrangers.

There are a fet of prints engraved after the Paintings on the cupola of St Paul's.